STEAM AROUND
LEEDS IN THE 1960s

KEITH W. PLATT

AMBERLEY

First published 2022

Amberley Publishing
The Hill, Stroud
Gloucestershire, GL5 4EP

www.amberley-books.com

Copyright © Keith W. Platt, 2022

The right of Keith W. Platt to be identified as
the Author of this work has been asserted in
accordance with the Copyrights, Designs and
Patents Act 1988.

ISBN 978 1 3981 0550 8 (print)
ISBN 978 1 3981 0551 5 (ebook)

British Library Cataloguing in Publication Data.
A catalogue record for this book is available from
the British Library.

Origination by Amberley Publishing.
Printed in the UK.

Introduction

In the late 1950s my interest in railways generally, and trainspotting in particular, led me and my friends to expand our spotting locations more and more. Doncaster had always been a rich source of interest and seeing the occasional ex-LMS locomotive passing through became the trigger to immerse ourselves in all things Stanier. We had already progressed from an Eastern Region Ian Allan book to a combined volume and a shed book, so locomotives with a four at the beginning of their number became as important as a loco beginning with a six.

Leeds became a very powerful magnet, drawing us towards it. It was only a relatively short train journey away, and within the city there were a number of engine sheds we could try to visit, as well as enjoying our time on the platforms at Leeds City station. There was one platform end longer than the others, which was especially popular with the spotting fraternity as you could oversee virtually all the comings and goings at the station. The authorities at Leeds City seemed to be more tolerant about having large groups of youngsters on the platforms than Doncaster, but occasionally we were moved on and had to find pastures new. Holbeck shed was quite close by and always worth a visit. I remember climbing the stone wall to peer through the broken windows of the roundhouse and turning up at the gate and being allowed to join a group visiting the shed. A railway embankment on the way to Holbeck was an unlikely gathering point for many spotters and it was usually thronged with young people perched on the heavy black-coated cables strung on short concrete posts along the track side like starlings on a telephone wire.

The Royal Scots and Jubilees were always a welcome sight and very regularly appeared, however my own favourites were the un-rebuilt Patriots and the Clans, which were more elusive. The five standard tank engines based at Neville Hill were also one of the memories I have of my first visits to Leeds.

During 1961 a total of seven Britannia Pacifics were transferred to Immingham depot and gradually began to appear passing through my local station of Thorne South. One train a day, they became regular performers on a Grimsby to Leeds direct service that used the Grimsby and West Riding link line between Stainforth and Adwick, allowing trains to avoid reversals at Doncaster. The train stopped at Thorne South at around 10.30 a.m. and returned about 5.00 p.m. These were ideal timings, enabling me to get to school for morning registration then sneak out between lessons, have a great day trainspotting in Leeds and return home without any suspicions being aroused! I have to say the temptation was too much to ignore on a couple of occasions.

By the mid-1960s cycling was high on my list of interests and it gave me another means of pursuing my railway interest. I devised several different cycle journeys that involved shed visits to depots in West Yorkshire, and one of my regular Sunday rides included stops at Normanton, Mirfield, Wakefield, Royston, back home through Barnsley, stopping at Mexborough (until 1964), and finally a look in at Doncaster shed and plant. I have to say most of the sheds were easy to access with a quick word to a member of staff, but Doncaster was never as welcoming for the casual visitor who turned up without a permit.

By the last days of steam in the West Riding my means of transport had changed once again; hitchhiking became the norm, or the adventures in an Isetta bubble car. By the winter of 1967

steam was at an end in West Yorkshire and my own enthusiasm for following the death throes of steam in the North West had greatly diminished.

All the images in the book are original slides and negatives from my collection, and the names of the photographers have been included where this is known.

I would like to thank my wife Andrea for her proofreading work, IT expertise, support and advice.

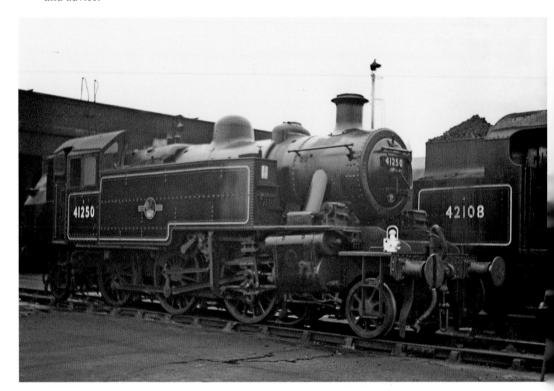

October 1962. LMS Ivatt 2MT 2-6-2T 41250, Low Moor MPD, Bradford.
LMS Ivatt 2MT 2-6-2T 41250 was built in November 1949 at Crewe Works and spent its entire working life in West Yorkshire. It was allocated to Low Moor MPD, Bradford, in June 1954 and remained there until April 1963, after which it spent a few months at Copley Hill MPD, Leeds, before withdrawal in November 1963. The introduction of diesel multiple units in late 1956 signalled the early demise for these locomotives in the Bradford area. The diesel multiple units had taken over many of the duties that the Ivatt tanks had been designed to do. This, together with the closure of several branch line routes in the area, made this engine redundant after just fourteen years of service.

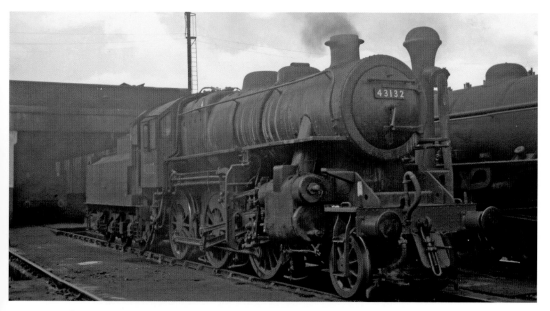

September 1964. LMS Ivatt 4MT 2-6-0 43132, Low Moor MPD, Bradford.
LMS Ivatt 4MT 2-6-0 43132 was a Horwich-built locomotive that entered service in November 1951, over three years after the formation of British Railways. It spent its first ten years of service in Scotland before reallocation to West Yorkshire, and the books of Low Moor MPD, in January 1964. It left Bradford for its final year of operation in the North East at Blyth North MPD, and was withdrawn in December 1966.

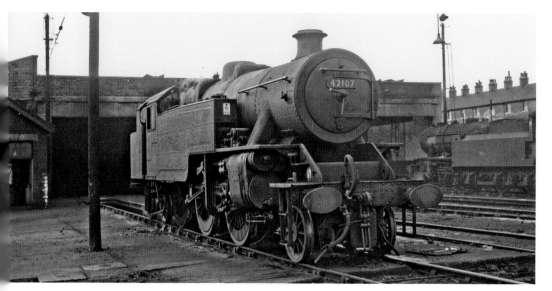

July 1964. LMS Fairburn 4MT 2-6-4T 42107, Low Moor MPD, Bradford.
LMS Fairburn 4MT 2-6-4T 42107 had emerged from Derby Works in March 1949 and within days had found its way to Low Moor MPD, which was to be its only home until finally being condemned in February 1966. Low Moor had become the last working depot for many of the surviving Fairburn tank engines. In 1966 five of the class, including 42107, were withdrawn from there and in 1967 a total of fourteen ended the days working from Low Moor.

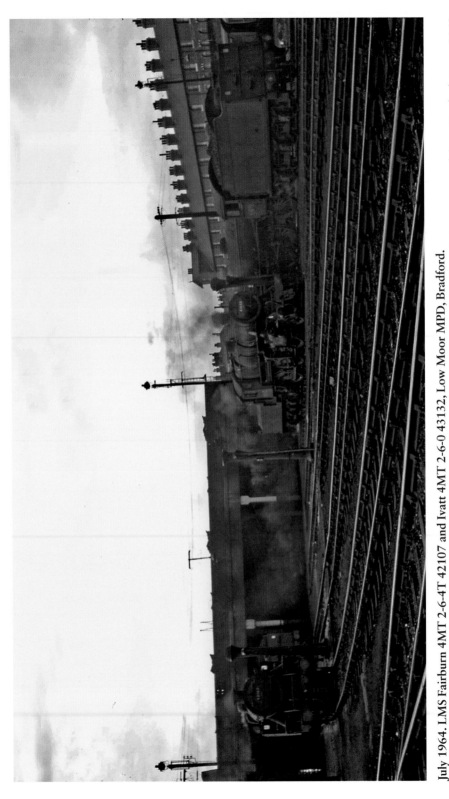

July 1964. LMS Fairburn 4MT 2-6-4T 42107 and Ivatt 4MT 2-6-0 43132, Low Moor MPD, Bradford.
A view of the shed yard at Low Moor MPD showed a number of locomotives in steam and awaiting their next turn of duty. On the left was LMS Fairburn 4MT 2-6-4T 42107, and to the right was LMS Ivatt 4MT 2-6-0 43132. Next to 43132 was LNER B1 4-6-0 61023, a reminder that Low Moor MPD, although originally a Lancashire & Yorkshire Railway depot, had been transferred to the North Eastern Region in 1956.

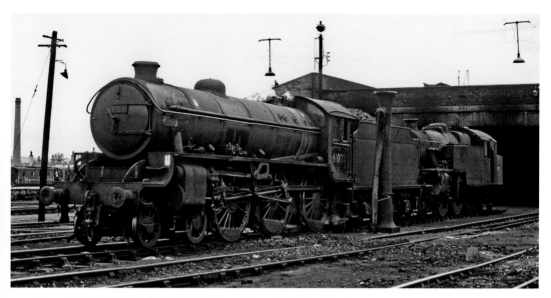

May 1965. LNER B1 4-6-0 61023, Low Moor MPD, Bradford.
LNER B1 4-6-0 61023 *Hirola* was built at Darlington in April 1947 and spent the first eleven years of service in the North East. It was a resident of Heaton, Gateshead, Darlington and York depots before finding a home at Low Moor in June 1958. It spent periods at several West Yorkshire depots before returning to Low Moor for a final eighteen-month spell of activity and was withdrawn in October 1965. Its final journey would see it return to the North East for cutting up at Hughes Bolckow's in North Blyth.

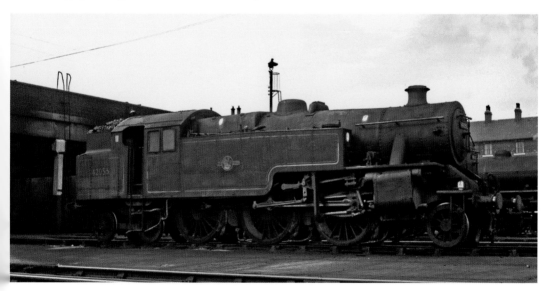

28 May 1965. LMS Fairburn 4MT 2-6-4T 42055, Low Moor MPD, Bradford.
LMS Fairburn 4MT 2-6-4T 42055 was another product of Derby Works and was put into traffic in October 1950. It spent its first thirteen years working mainly from Glasgow's Polmadie depot and came to West Yorkshire in October 1963. It found its way to Low Moor in January 1965 and was eventually withdrawn from there in June 1967. It is seen here after withdrawal awaiting its final journey to Cashmore's yard at Great Bridge, Birmingham.

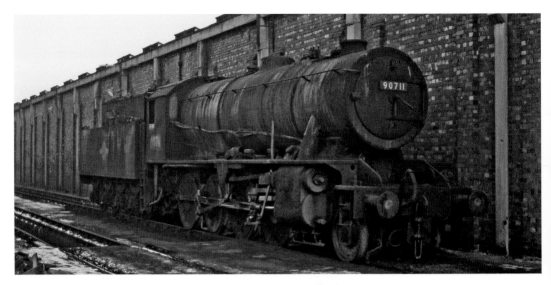

January 1967. WD 2-8-0 90711, Low Moor MPD, Bradford.
WD 2-8-0 90711 was built in February 1945 for the War Department by the Vulcan Foundry. It was quickly transported to mainland Europe to aid the efforts to win the Second World War and was put to work on the French National Railway (SNCF). It returned to England in 1947 and stored at Swindon before taking its turn to be overhauled and put into service with British Railways in June 1950. It spent its working life in West Yorkshire and found its way to Low Moor MPD in November 1966. However, it was withdrawn by the time this photograph had been taken in January 1967. (L. Flint)

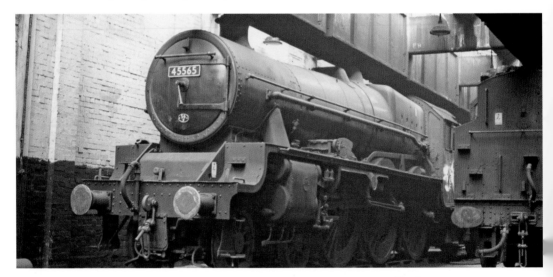

January 1967. LMS Stanier Jubilee 4-6-0 45565, Low Moor MPD, Bradford.
LMS Stanier Jubilee 4-6-0 45565 *Victoria* was built in August 1934 by the North British Locomotive Company in Glasgow to the design of the recently appointed Chief Mechanical Engineer of the LMS, William (later Sir) Stanier. It was a West Yorkshire-allocated locomotive throughout its British Railway's career and arrived at Low Moor MPD in June 1962. Other than a four-month period in 1965 when it worked from Wakefield, it remained faithful to Bradford until withdrawal in January 1967. (L. Flint)

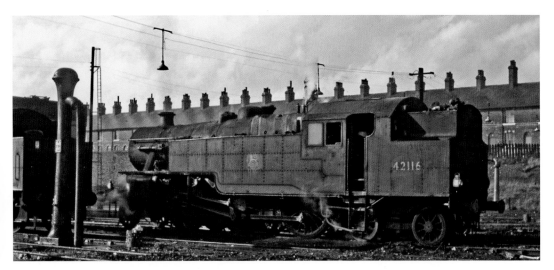

19 February 1967. LMS Fairburn 4MT 2-6-4T 42116, Low Moor MPD, Bradford.
LMS Fairburn 4MT 2-6-4T 42116 was built at Derby Works in July 1949 and, although officially allocated to Stoke MPD, it was immediately loaned to Low Moor MPD and was to remain at Bradford until withdrawal from service in June 1967. It is worth noting the 'cycling lion' emblem on the locomotive because these were last applied at loco repaints in 1956. 42116 had been wearing its 'cycling lion' for at least eleven years. Also of note is the row of terraced houses, aptly named Railway Terrace, which are still there today, although much altered externally with brightly painted and rendered walls. I wonder whether the estate agents of the 1960s used the 'excellent views of the loco depot' as a selling point for these two-bedroom terraced houses? (L. Flint)

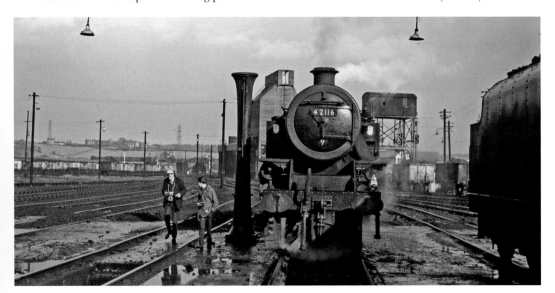

19 February 1967. LMS Fairburn 4MT 2-6-4T 42116, Low Moor MPD, Bradford.
LMS Fairburn 4MT 2-6-4T 42116 displays a carefully painted front number plate and a polished smokebox door as it is prepared for its next duty. The whole scene has now been transformed with no sign of the depot or the adjacent sidings. In 2008 the Raw Nook Heathland nature reserve was established on the 13-acre site by Bradford Council, which now has established woods and wild flower meadows. (L. Flint)

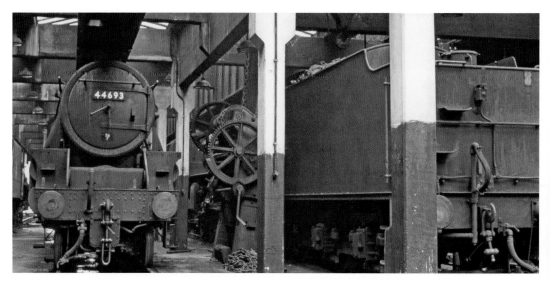

19 February 1967. LMS Stanier Black Five 4-6-0 44693, Low Moor MPD, Bradford.
LMS Stanier Black Five 4-6-0 44693 was the first of three similar locomotives delivered new to Low Moor MPD in November 1950. Apart from a two-year period at Mirfield MPD, they were to remain in Bradford throughout their careers, with 44693 being withdrawn in May 1967.

The hand-operated shear legs over the adjacent road, with its large hook above the tender of the B1, was used to lift locomotives in order to do maintenance work on their wheels, springs and axle-boxes. This piece of Victorian technology was still in everyday use right up to the end of steam. (L. Flint)

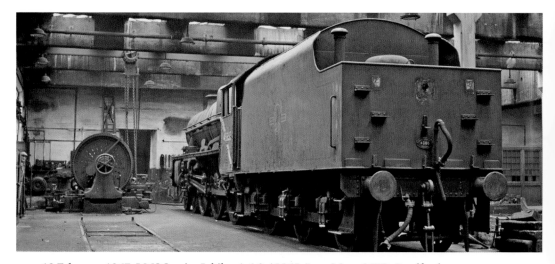

19 February 1967. LMS Stanier Jubilee 4-6-0 45565, Low Moor MPD, Bradford.
LMS Stanier Jubilee 4-6-0 45565 *Victoria* was one of many locomotives reallocated to Low Moor MPD after they had been displaced from their previous depots by diesels. In the case of 45565 it had moved from Holbeck MPD in June 1962. Low Moor depot was a straight twelve-road shed with entry at the north end. In its latter days the six roads on the eastern side retained the overall roof but the other six roads lost theirs. Heavy machinery such as the shear legs and the wheel lathe seen in this photograph were situated at the eastern side of the depot and remained available for use until October 1967. (L. Flint)

March 1967. LMS Fairburn 4MT 2-6-4T 42184, Low Moor MPD, Bradford.
LMS Fairburn 4MT 2-6-4T 42184 was built at Derby Works in January 1949 and now stands withdrawn on one of the shed roads, which were roofless in the last days of steam. The locomotive had spent much of its working life in the East Midlands and had arrived on Low Moor's books in June 1966 but was withdrawn within six months. It was being prepared for its final journey to Thomas Ward of Killamarsh, and would be cut up within weeks of this photograph, to help feed the blast furnaces of South Yorkshire.

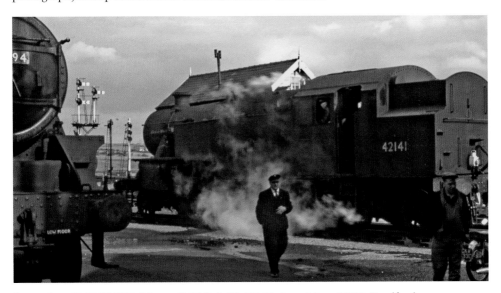

September 1967. LMS Fairburn 4MT 2-6-4T 42141, Low Moor MPD, Bradford.
LMS Fairburn 4MT 2-6-4T 42141 was built at Derby Works in April 1950 and was based in West Yorkshire depots throughout its career. It was reallocated to Low Moor MPD in May 1967 and would remain active until September of that year, when steam passenger workings from Bradford ceased.

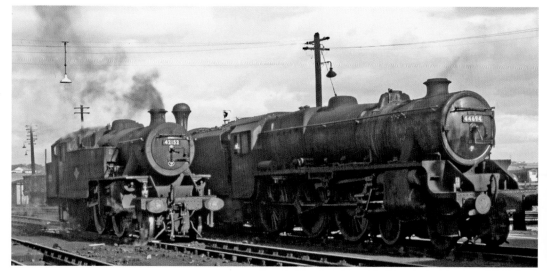

September 1967. LMS 42152 and 44694, Low Moor MPD, Bradford.
LMS Fairburn 2-6-4T 42152 was another product of Derby Works being built in June 1948. Its first allocation had been to Sowerby Bridge MPD and from there it moved to various other West Yorkshire depots. It had just become a Low Moor engine but would be withdrawn within weeks of arrival. LMS Stanier Black Five 4-6-0 44694 had been built at Horwich in November 1950, which was almost three years after the formation of the nationalised British Railways. It had been a Low Moor engine from new, other than a two-year sojourn at Mirfield. It returned to Low Moor MPD in September 1966 and was finally withdrawn from there in October 1967.

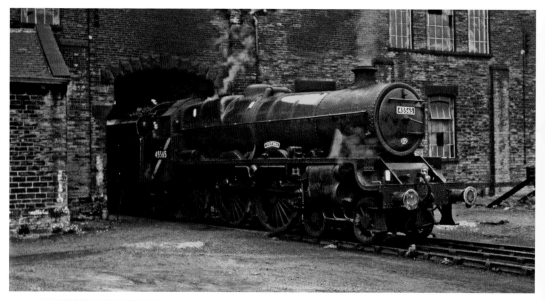

24 September 1966. LMS Jubilee 4-6-0 45565, Manningham MPD, Bradford.
LMS Stanier Jubilee 4-6-0 45565 *Victoria* had been a Low Moor engine since June 1962 but had been prepared at Manningham depot to work an enthusiasts special from Bradford Foster Square station. It was to head the train to Glasgow and back, with a stopover at Carlisle Kingmoor MPD on the outward journey to allow the passengers to visit the shed.

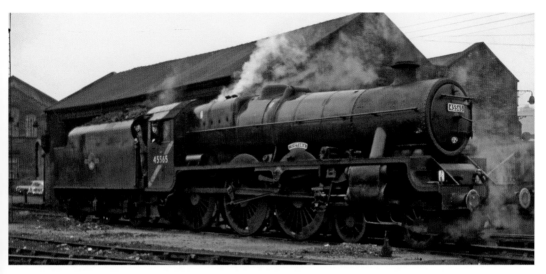

24 September 1966. LMS Jubilee 4-6-0 45565, Manningham MPD, Bradford.
LMS Stanier Jubilee 4-6-0 45565 *Victoria*, looking clean and well coaled, prepares to move off Manningham depot to head the Jubilee Railway Society's 'The South Yorkshireman No. 6 Rail Tour' from Bradford to Glasgow Central and return. The route would include travelling over the Settle & Carlisle line and climbing Beattock.

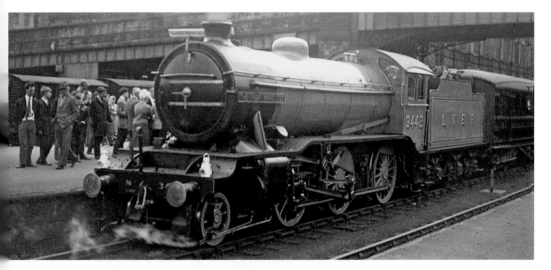

4 May 1963. LNER K4 2-6-0 3442, Bradford Forster Square station.
LNER K4 Class 2-6-0 3442 *The Great Marquess* was built in July 1938 at Darlington Works. It was the second in the class of six locomotives designed to cope with the traffic on the West Highland line, particularly the Glasgow to Fort William section. They were replaced on this line with more powerful engines; at the end of 1959 five of the class were reallocated to Thornton Junction. In December 1961, 61994, by then the last of the class still in service, was withdrawn. It was bought by Viscount Garnock and overhauled at Cowlairs Works. The locomotive was based at Neville Hill MPD and hauled rail tours on the BR network from May 1963 until April 1967. It was withdrawn for boiler repairs, which were not proceeded with because of the forthcoming end of steam on British Railways. 3442 remained stored at Neville Hill until it moved to the Severn Valley Railway in 1972.

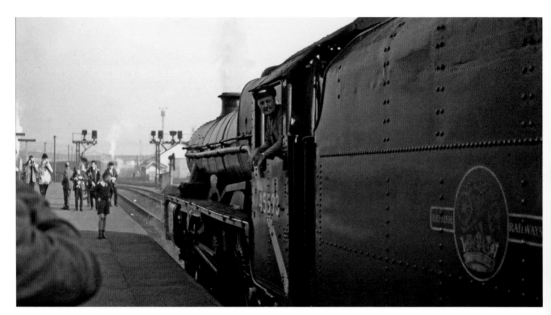

30 April 1966. LMS Stanier Jubilee 4-6-0 at 45593 departs Bradford Forster Square station.
LMS Stanier Jubilee 4-6-0 45593 *Kolhapur* awaits departure from Bradford Forster Square station with the Jubilee Railway Society's 'South Yorkshireman No. 5 Rail Tour'. The tour would visit Carnforth before continuing up the West Coast main line to Carlisle with visits to Upperby and Kingmoor depots. At Carlisle 45593 was failed with mechanical problems and BR Britannia 70035 returned the tour to Bradford via the Settle & Carlisle line. (L. Flint)

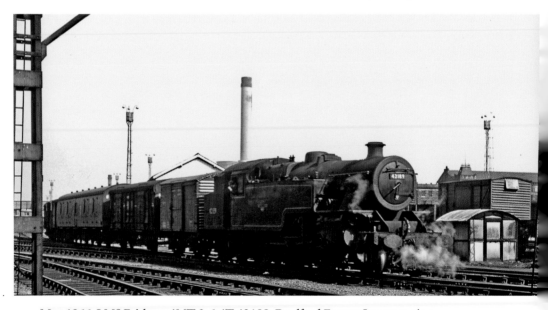

May 1966. LMS Fairburn 4MT 2-6-4T 42189, Bradford Forster Square station.
LMS Fairburn 4MT 2-6-4T 42189 was built at Derby Works in December 1947 and was based at Low Moor MPD in Bradford throughout most of its career. In May 1967 it moved to Wakefield and then Normanton before withdrawal in September 1967. It was seen during its days working around Bradford shunting parcels stock at Forster Square station.

30 April 1966. LMS Stanier Jubilee 4-6-0 45593 departs Bradford Forster Square.
LMS Stanier Jubilee 4-6-0 45593 *Kolhapur* heads the Jubilee Railway Society's 'South Yorkshireman No. 5 Rail Tour' out of Bradford. The Holbeck-based locomotive had been a late replacement for Low Moor's 45565 *Victoria*, which was unavailable to work the train. *Kolhapur* worked the special to Carnforth and on to Carlisle, which had included a spirited climb up Shap, but was declared a failure at Carlisle.

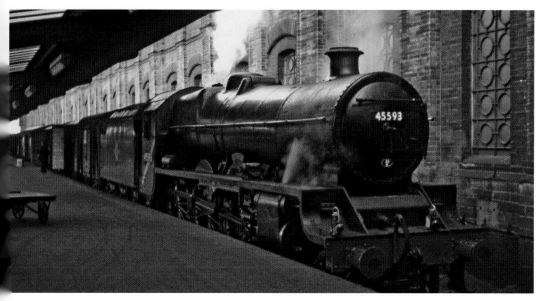

May 1967. LMS Stanier Jubilee 4-6-0 45593, Bradford Forster Square station.
LMS Stanier Jubilee 4-6-0 45593 *Kolhapur* had become one of the few active Jubilees that had survived into 1967 and was in popular demand for rail tour duties and Saturday-only passenger workings. In between these high profile jobs it was kept busy on more mundane tasks, as seen here in Bradford working a parcels train.

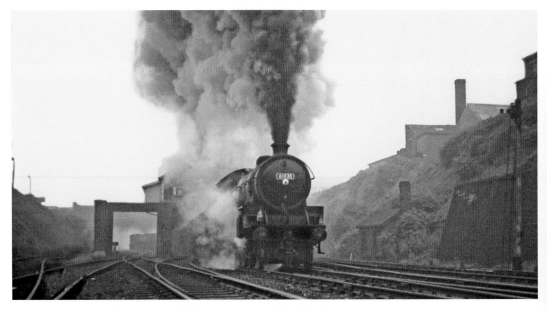

July 1967. LNER B1 4-6-0 61030 storms out of Bradford.
LNER B1 4-6-0 61030 *Nyala* was built for the LNER at Darlington Works in June 1947. It spent the fourteen years working in the North East before reallocation to West Yorkshire in July 1961. It found its way to Low Moor in July 1967 and was one of the last three B1 locomotives in active service, being withdrawn in Sepember 1967. *Nyala* rattles the windows as it passes beneath the Laisterdyke West Junction signal box soon after departing Bradford.

August 1967. LMS Fairburn 4MT 2-6-4T 42141, Bradford Exchange station.
LMS Fairburn 2-6-4T 42141 brings stock under the magnificent double-arched roof of the station. Bradford Exchange station, with its ten platforms, was a shadow of its former self by the summer of 1967 and within a few weeks of these photographs would lose its steam-hauled services. Many destinations had already disappeared from the timetable after line closures earlier in the year and the station itself was soon to follow them.

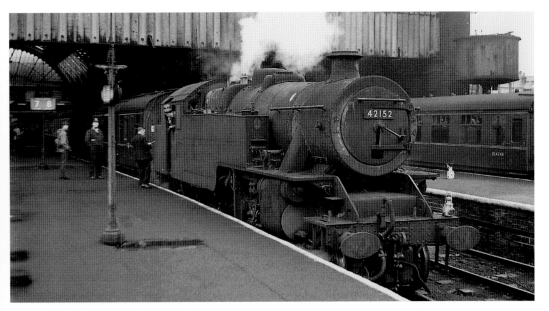

August 1967. LMS Fairburn 4MT 2-6-4T 42152, Bradford Exchange station.
LMS Fairburn 2-6-4T 42152 awaits departure from Bradford Exchange with a service to Leeds. 42152 had only just returned to a Bradford depot after spending time at Holbeck and Wakefield. The locomotive had the distinction of hauling the last Eastern Region scheduled steam passenger train, which was the 4.18 p.m. Bradford to Leeds on 1 October 1967. It was withdrawn very soon afterwards, its services no longer required with the end of steam in the area.

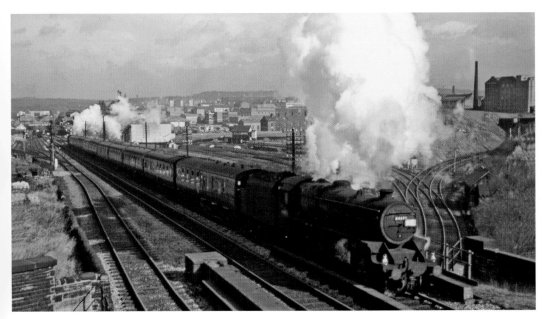

July 1965. LMS Stanier Black Five 4-6-0 44693 heads out of Bradford at St Dunstan's.
LMS Stanier Black Five 4-6-0 44693, a long-time resident of Low Moor depot, heads a seaside excursion train out of Bradford on the L&Y line to Halifax. It passes over the GN Queensbury line with the St Dunstan's carriage sidings to the right of the train.

19 August 1967. LMS Stanier 4MT 2-6-4T 42616 banking out of Bradford.
LMS Stanier 4MT 2-6-4T 42616 was built by the North British Locomotive Company in February 1937 and worked in many locations in its long career. It finally found its way to Low Moor in June 1967 and remained active until the end of steam in the Bradford area.

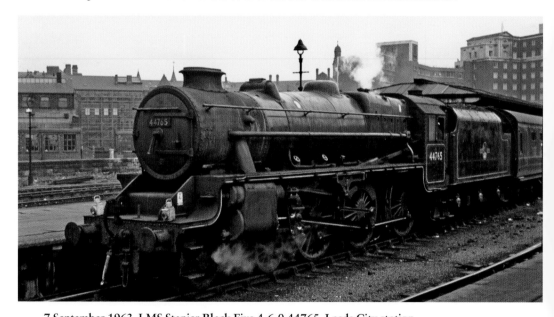

7 September 1963. LMS Stanier Black Five 4-6-0 44765, Leeds City station.
LMS Stanier Black Five 4-6-0 44765 was one of two similar locomotives built at Crewe in late 1947 that differed from their classmates in having a double chimney, Timken roller bearings and electric lighting. 44765 was to remain a faithful servant to Crewe all its working life; first allocated to Crewe North MPD until May 1965 when it was transferred to Crewe South before it was finally withdrawn in September 1967.

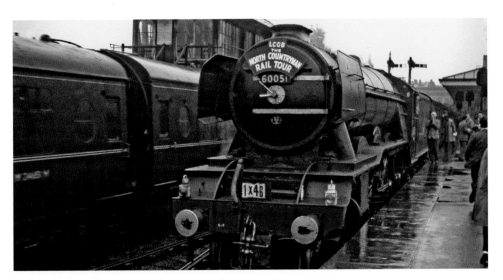

6 June 1964. LNER A3 4-6-2 60051, Leeds City station.
LNER A3 4-6-2 60051 *Blink Bonny* was built at Doncaster Plant Works in November 1924 and spent three years working from Copley Hill MPD before heading to various depots in the North East in September 1957. It is seen at the head of a Locomotive Club of Great Britain special 'The North Countryman Rail Tour', which it returned to London Kings Cross. The sight of an A3 at Leeds City was a pleasant reminder of the nine A3s that were allocated to Holbeck depot from 1960, and which proved so successful in working expresses over the Settle & Carlisle line. The last of that group had been reallocated away by 1963 and most had been withdrawn. The remainder of the class were withdrawn by late 1964, including 60051. The one exception was 60052, which lingered on until January 1966. *Flying Scotsman* had already been bought privately and preserved by the time of the photograph.

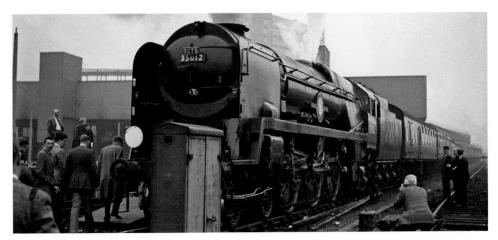

13 June 1964. SR Merchant Navy 4-6-2 35012, Leeds City station.
SR Merchant Navy 4-6-2 35012 *United States Lines* was built at Eastleigh Works in January 1945 and rebuilt there in its final form in 1957. It had been a Nine Elms-allocated locomotive for most of its career apart from a few years spent at Weymouth. It is seen at Leeds City at the head of 'The Solway Ranger' railtour, which had been organised by the West Riding branch of the RCTS. The train was hauled by 35012 from Leeds to Penrith via Carnforth, and it then hauled the tour back to Leeds from Carlisle. (L. Flint)

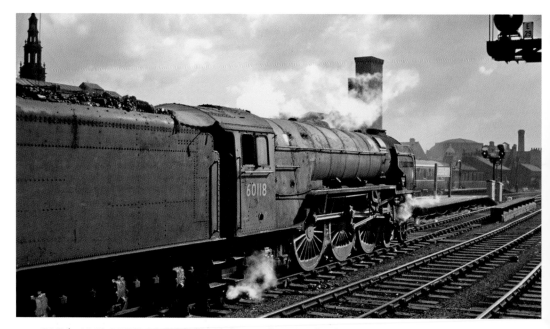

31 July 1965. LNER A1 4-6-2 60118 departs from Leeds City station.
LNER A1 4-6-2 60118 *Archibald Sturrock* was built at Doncaster Plant Works in November 1948 and had always been a Leeds-allocated locomotive. It began its career working from Copley Hill MPD, then moved on to Ardsley for just over six months before its final allocation in September 1963 to Neville Hill depot. It remained there until withdrawal in October 1965.

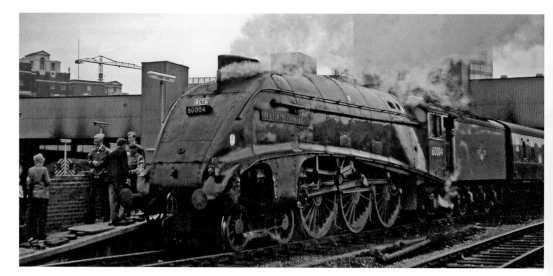

19 September 1965. LNER A4 4-6-2 60004 departs from Leeds City station.
LNER A4 4-6-2 60004 *William Whitelaw* was built at Doncaster Plant Works in December 1937 and after its first allocation to Kings Cross depot it became a Scottish-based locomotive from July 1941. Its final move was to Aberdeen Ferryhill MPD in June 1963 and it was withdrawn from there in July 1966. It is seen here heading the RCTS 'Blyth and Tyne Rail Tour' from Leeds on the first leg of the special to Eaglescliffe. It would return the special to Leeds from near Newcastle later in the day.

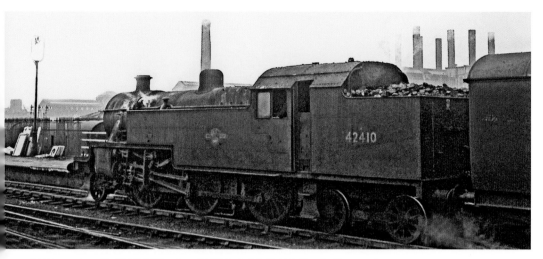

11 December 1965. LMS Fowler 4MT 2-6-4T 42410, Leeds City station.
LMS Fowler 4MT 2-6-4T 42410 was built at Derby Works in October 1933 and spent most of its working life at Huddersfield Hillhouse MPD. It was seen on familiar territory at Leeds City station about to leave on a local passenger train. It was to become the last Fowler 4MT tank engine to be withdrawn when it finally succumbed in September 1966, lasting just three months longer than Holbeck's survivor 42394. (M. Fowler)

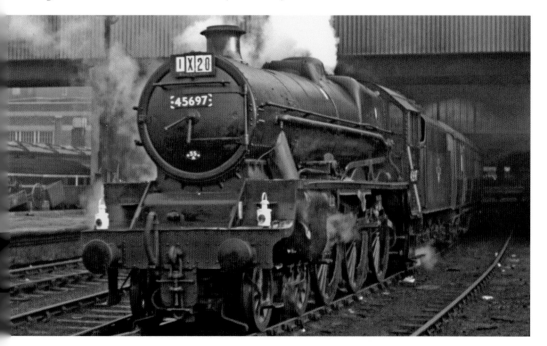

11 December 1965. LMS Stanier Jubilee 4-6-0 45697, Leeds City station.
LMS Stanier Jubilee 4-6-0 45697 *Achilles* was built at Crewe Works in April 1936 and was allocated at various depots in the North West of England before becoming a Holbeck locomotive in April 1964. It was to remain active there until it was withdrawn in September 1967. It is seen waiting at Leeds City station to take over the arriving Warwickshire Railway Society's 'Waverley Rail Tour' and head the special over the Settle & Carlisle line to Carlisle Citadel. (M. Fowler)

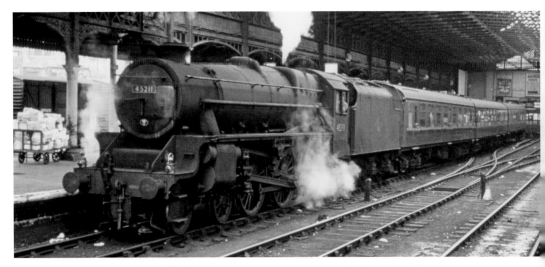

April 1966. LMS Stanier Black Five 4-6-0 45211 departs Leeds City station.
Stanier Black Five 4-6-0 45211 was part of a batch of a hundred Black Fives built by Armstrong Whitworth for the LMS in 1935, appearing in traffic in November of that year. It had always been a West Yorkshire-allocated locomotive, other than a six-month spell out of the area in 1950. The locomotive started life at Low Moor, then moved on to Farnley and Stourton before ending its service at Holbeck in May 1967. It was photographed as it was about to depart from what was the original Wellington terminus station, the through platforms of Leeds City station being a later addition by the North Eastern Railway and the London & North Western Railway. (M. Fowler)

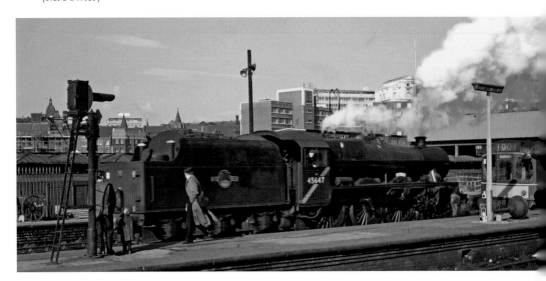

11 October 1966. LMS Stanier Jubilee 4-6-0 45647, Leeds City station.
LMS Stanier Jubilee 4-6-0 45647 *Sturdee* was built at Crewe Works in January 1935. It had led a fairly nomadic life moving to various sheds along the WCML before settling around Birmingham. Its final move was to West Yorkshire, first to Farnley Junction MPD in February 1964. This ensured it would become one of the Leeds 'celebrity' Jubilees, much admired in the last days of steam. When Farnley closed it moved to Holbeck MPD for its last six months of service.

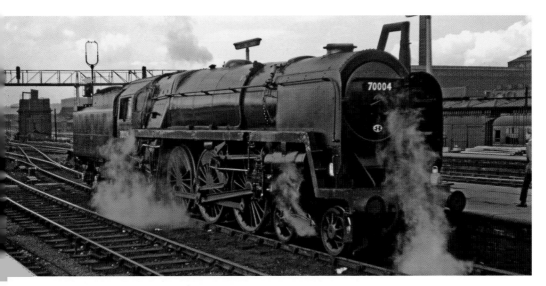

11 October 1966. BR standard 7MT 70004, Leeds City station.
BR standard Britannia 7MT 4-6-2 70004 was originally named *William Shakespeare* but, by the time of its last overhaul at Darlington in December 1965, it had lost its nameplates. It was built at Crewe Works in March 1951 and for the first seven years of its career was allocated to the Southern Region depot Stewart's Lane, where it was the primary motive power for the 'Golden Arrow'. When these duties ended in July 1958 it was transferred to nine different depots before ending its last few months in service at Carlisle Kingmoor. It was finally withdrawn in December 1967.

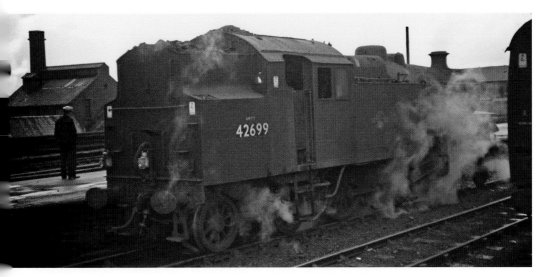

11 October 1966. LMS Fairburn 4MT 2-6-4T 42699, Leeds City station.
LMS Fairburn 4MT 2-6-4T 42699 was built at Derby Works in October 1945 and was in the first batch of these locomotives to be produced. It had spent its first eight years in service in Scotland. It was transferred to Leeds Neville Hill MPD in October 1963, then on to Holbeck in June 1966. During its final general overhaul at Crewe in early 1965 it received an unlined black livery. It was finally withdrawn from service in May 1967 and scrapped at Draper's Sculcoates yard in Hull at the end of October 1967.

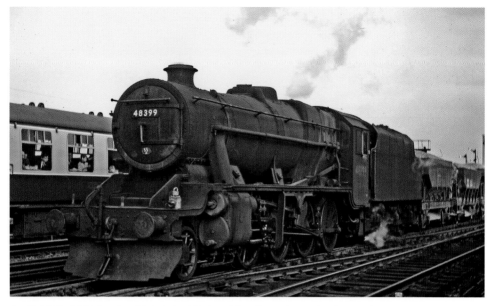

April 1967. LMS Stanier 8F 2-8-0 48399 ambles through Leeds City station.
LMS Stanier 8F 2-8-0 48399 was built at Horwich Works in June 1945 and after early allocation in the East Midlands found a home at Holbeck MPD in February 1948, where it was to remain allocated until withdrawal in September 1967. It had been fitted with a small snowplough at some point in its career, which would probably see no more use before the locomotive's withdrawal.

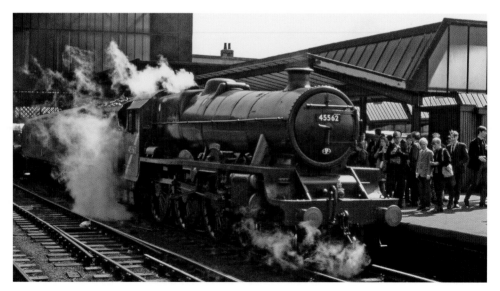

May 1967 LMS Stanier Jubilee 4-6-0 45562, Leeds City station.
LMS Stanier Jubilee 4-6-0 45562 *Alberta* had become a celebrity locomotive by May 1967, one of a trio of Holbeck-based survivors of the class to receive a lot of attention from shed staff and enthusiasts who kept them looking immaculate. The engines were in high demand throughout the summer to haul enthusiast specials and rail tours, as well as undertake important express passenger duties over the Settle & Carlisle line.

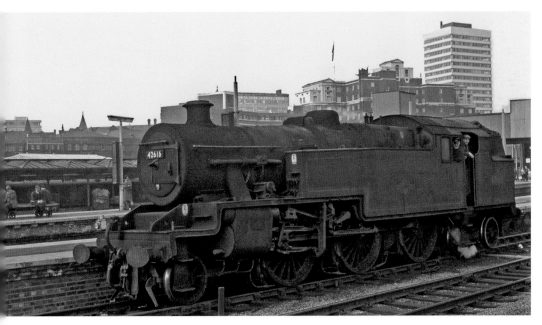

13 May 1967. LMS Stanier 4MT 2-6-4T 42616 departs Leeds City station.
LMS Stanier 4MT 2-6-4T 42616 had been built by the North British Locomotive Company in February 1937. It had been allocated to many different depots in the old LMS territory and was a latecomer to West Yorkshire when allocated to Low Moor, Bradford, in June 1967. Within three months it had been withdrawn.

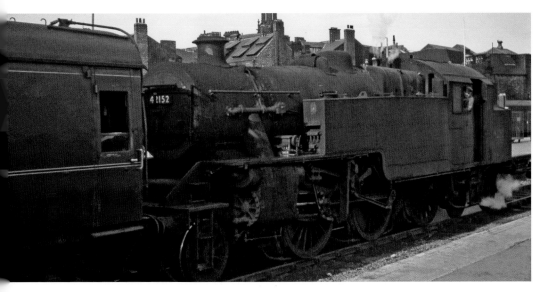

5 July 1967 LMS Fairburn 4MT 2-6-4T 42152, Leeds City station.
LMS Fairburn 4MT 2-6-4T 42152 was built at Derby Works in April 1950 and had always been allocated to West Yorkshire depots. It was based at Bradford's Manningham depot at the time of the photograph and was about to depart on a passenger working to Leeds. Its final allocation was to Low Moor depot in late August 1967, however, its stay was to be short lived as it was withdrawn in October 1967.

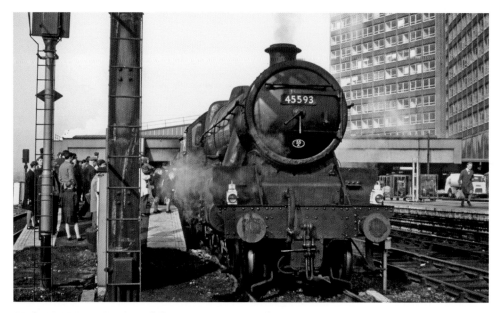

9 July 1967. LMS Stanier Jubilee 4-6-0 45593, Leeds City station.
LMS Stanier Jubilee 4-6-0 45593 *Kolhapur* was a comparative latecomer to West Yorkshire, being reallocated Holbeck MPD in April 1965. It was, however, one of the last three of the class in active service, and after withdrawal in October 1967 was selected for preservation by the late Patrick Whitehouse for the then 'Standard Gauge Steam Trust', which later became the 'Tyseley Locomotive Works' based at the old Tyseley MPD.

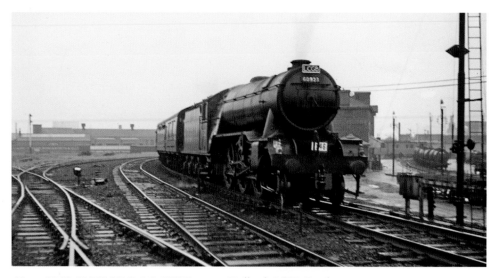

6 June 1964. LNER V2 2-6-2 60923 passes Holbeck MPD, Leeds.
LNER V2 2-6-2 60923 was built at Darlington Works in November 1941 and was based in the North East until December 1962, when it was reallocated to Ardsley MPD. It was eventually withdrawn from there in October 1965. It was photographed as it passed Holbeck MPD while heading the LCGB North Countryman Rail Tour. The V2 had taken over the special at Whitehall Junction in Leeds and was to take the Settle & Carlisle line to Carlisle and then return to Leeds City station via Shap and Settle Junction.

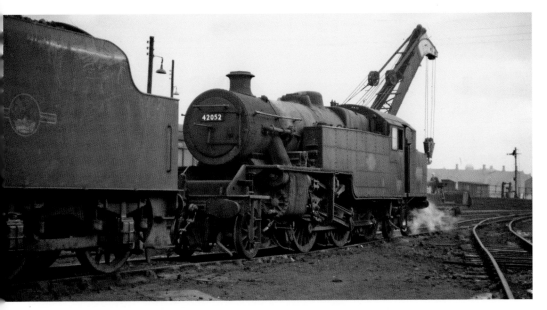

March 1966. LMS Fairburn 4MT 2-6-4T 42052. Holbeck MPD, Leeds.
LMS Fairburn 4MT 2-6-4T 42052 had been built at Derby Works in September 1950 and was based at either Bradford Manningham MPD or Holbeck MPD throughout its active life. It was finally withdrawn from Holbeck in May 1967 and was cut-up by Draper's of Hull in October of that year.

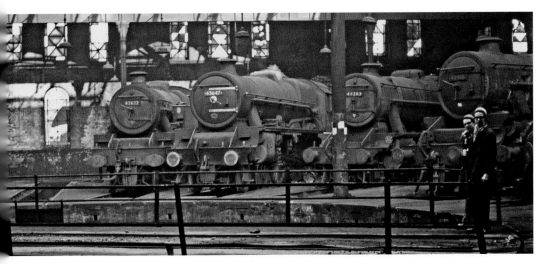

January 1967. 42622, 45647, 48283 and 44988 waiting at Holbeck MPD, Leeds.
A selection of different Stanier-designed locomotives gathered around the turntable in the roundhouse of Holbeck MPD. From left to right: 4MT 2-6-4T 42622, Jubilee 4-6-0 45647 *Sturdee*, 8F 2-8-0 48283, and Black Five 4-6-0 44988. The "Black Five" was a visitor from Stockport Edgeley MPD, while all the others were Holbeck residents. The 4MT and the 8F had probably come to the end of their active lives as they were days away from withdrawal. 45647 *Sturdee* was to soldier on through to September before withdrawal and the Black Five was finally withdrawn in December 1967. The irregular patterns created by the sunlight through the damaged windows and the two peering enthusiasts complete the scene. (L. Flint)

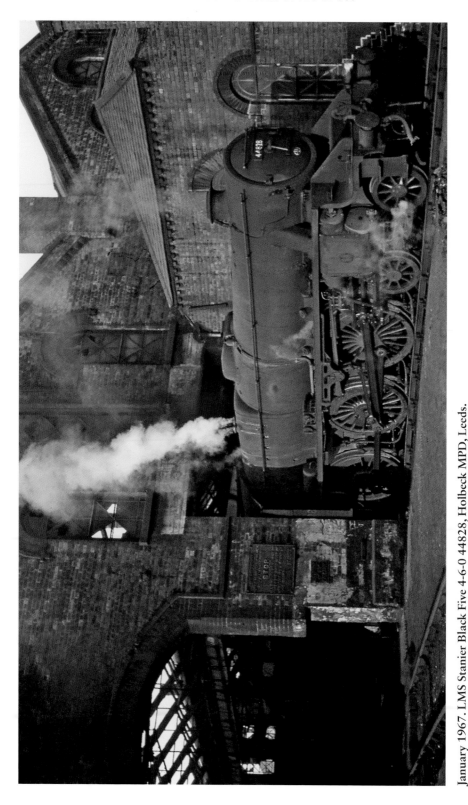

January 1967. LMS Stanier Black Five 4-6-0 44828, Holbeck MPD, Leeds.
LMS Stanier Black Five 4-6-0 44828 was built at Crewe in July 1944 and had spent much of its career at Holbeck. It was to see one last summer of active service before withdrawal in September of 1967, the same month that the depot was to close to steam. (L. Flint)

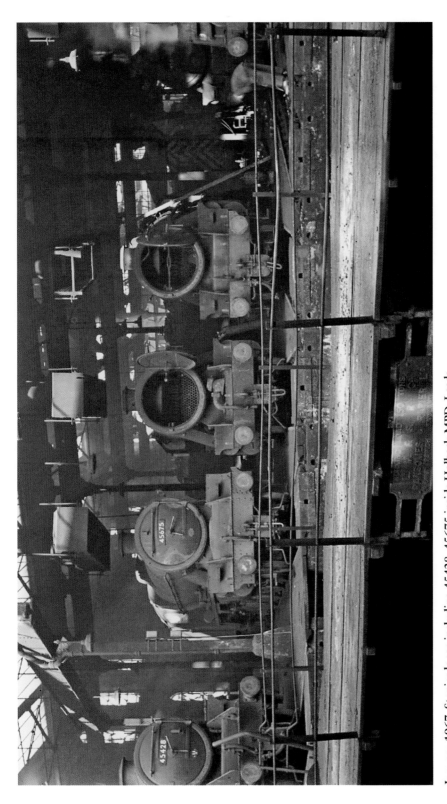

January 1967. Stanier locos including 45428, 45675 inside Holbeck MPD, Leeds.
Stanier Black Five 4-6-0 45428 was built by Armstrong Whitworth in October 1937 and had been reallocated to Holbeck MPD in December 1955. It then spent seven years allocated to Farnley MPD and returned to Holbeck in January 1967 for its last ten months of active service. Jubilee 4-6-0 45675 *Hardy* was one of the last five of the class to see any action into 1967 and was finally withdrawn in June of that year. (L. Flint)

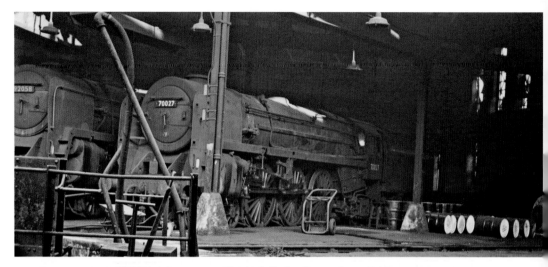

January 1967 BR Britannia 4-6-2 70027 and 9F 92058 inside Holbeck MPD, Leeds.
BR Britannia 4-6-2 70027 was built at Crewe Works in October 1952 and spent the first nine years of its career working on the Western Region from Cardiff Canton MPD. It led a nomadic existence, working for relatively short periods from many depots. Eventually it became a Carlisle Kingmoor-based locomotive in October 1966 and in common with many named locos quickly lost its *Rising Star* nameplates. BR standard 9F 2-10-0 92058 had been built at Crewe in October 1955 and had been based at a number of depots in the East Midlands before its transfer to Warrington in March 1965. It was eventually withdrawn from Carlisle Kingmoor in November 1967.

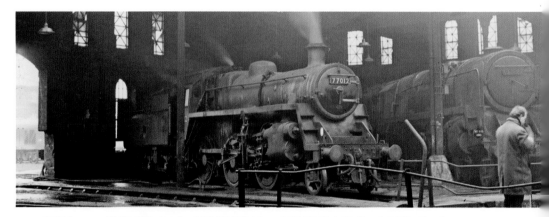

19 February 1967. BR standard 3MT 77012 and 9F 92204, Holbeck MPD, Leeds.
BR standard 3MT 2-6-0 77012 was built at Swindon in June 1954; it was one of ten locomotives of the type allocated to depots in the North Eastern Region of British Railways. 77012 had served at ten depots from West Auckland to Goole before returning to York MPD in April 1966. It was to be withdrawn in June 1967. BR standard 9F 2-10-0 92204 was another product of Swindon Works in April 1959 and was a Western Region-allocated locomotive until August 1966 when it was transferred to Speke Junction MPD, from where it was withdrawn in December 1967. The engine's claim to fame occurred in March 1960, when it successfully worked an eleven-coach test train over the Somerset & Dorset line between Bath and Bournemouth West. This led to the reallocation of a number of 9Fs each summer to Bath Green Park MPD to work the heavy holiday traffic. (L. Flint)

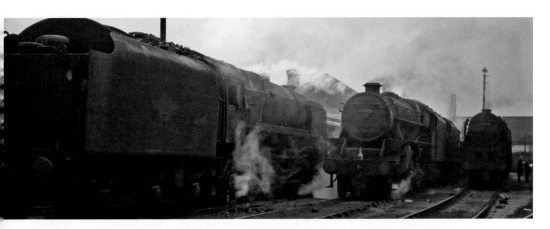

19 February 1967. BR standard 9Fs 92101 and 92211 with 45075, Holbeck MPD, Leeds.
BR standard 9F 2-10-0 92101 was built at Crewe Works in August 1956 and was allocated to depots in the East Midlands before moving to Birkenhead Mollington Street MPD in April 1965. It had hauled one of the regular Stanlow, Cheshire, to Leeds oil trains over the Pennines and was being prepared for the return trip with empties. The other 9F, 92211 had been built at Swindon Works in September 1959 and after a couple of years at Old Oak Common MPD was transferred to the Southern Region. Another move in September 1963 brought it north to York MPD, but with little work there, it moved for one last time to Wakefield in November 1966 and was withdrawn in May 1967. LMS Black Five 4-6-0 45075 was a product of the Vulcan Foundry in February 1935, had been allocated to Farnley MPD at the dawn of British Railways in January 1948, and became a resident of Holbeck in September 1964. It spent the last two months of active service at Normanton and was withdrawn from there in September 1967. (L. Flint)

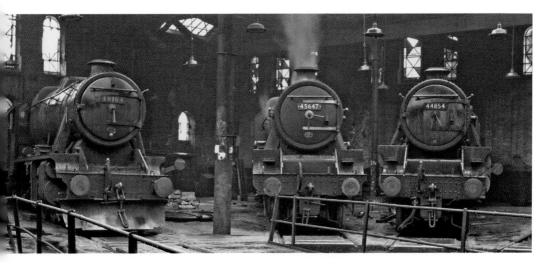

19 February 1967. Stanier locos 48104, 45647 and 44854, Holbeck MPD, Leeds.
Stanier 8F 2-8-0 48104 was built at Crewe Works in February 1939 and was allocated to Holbeck MPD in January 1948; it was to be withdrawn in July 1967. It was another of Holbeck's 8Fs to be fitted with a small snowplough. Jubilee 4-6-0 45647 *Sturdee* was being readied to leave the shed in preparation for its next duty – it was to have a few more weeks of work before withdrawal in April. Finally Black Five 4-6-0 44854, which had been a Holbeck stalwart since nationalisation, was to be transferred to Normanton in July 1967. It was withdrawn at the end of September.

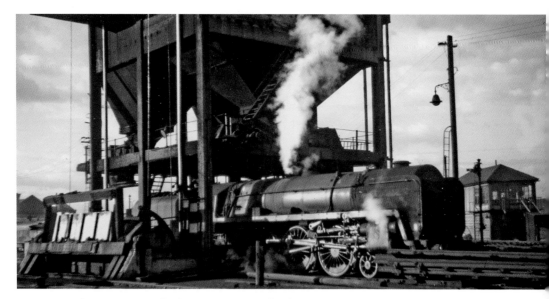

18 April 1967. BR standard 7MT 70048, Holbeck MPD, Leeds.
BR standard Britannia 7MT 4-6-2 70048 was previously named *The Territorial Army 1908–1958*, but no longer carried any nameplates. It was built at Crewe in July 1954 and served at a number of depots from Holyhead to Willesden before its final transfer in October 1964 to Carlisle. Although 70048 looked in reasonable condition as it shunted under the coaling plant at Holbeck, it was to remain in active service for only a few more weeks and may well have been on its last visit to Leeds.

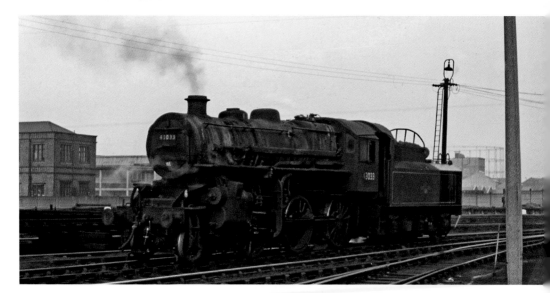

18 April 1967. LMS Ivatt 4MT 2-6-0 43033, Holbeck MPD, Leeds.
LMS Ivatt 4MT 2-6-0 43033 was built at Horwich Works in May 1949. It had spent a long time working in the East Midlands and Birmingham before moving to the North West. In November 1965 it was reallocated to Tebay MPD and a few weeks after this photograph it made its last move to Lostock Hall MPD, from where it was finally withdrawn in March 1968. It was seen moving off Leeds Holbeck MPD for its next duty.

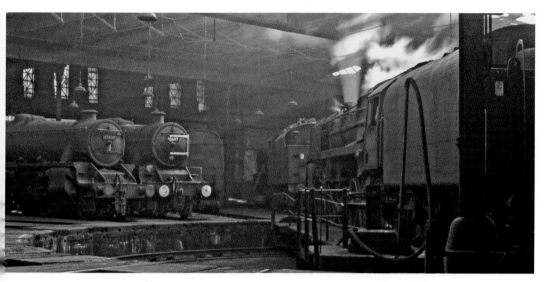

13 June 1967. LMS Black Five 4-6-0 45080 with 45697 and a 9F, Holbeck MPD, Leeds.
Stanier Black Five 4-6-0 45080 was built at the Vulcan Foundry in March 1935 and had been a Leeds-based locomotive from the dawn of British Railways in January 1948. It was allocated to Farnley MPD for a long period and had a spell at Stourton depot before its final reallocation to Holbeck in January 1967. Alongside was LMS Stanier Jubilee 4-6-0 45697 *Achilles* and they would work through the summer of 1967 until the depot's closure to steam on 1 October when 45080 was also withdrawn. The unidentified 9F was being turned ready for its return journey over the Pennines with oil empties for Stanlow, Cheshire.

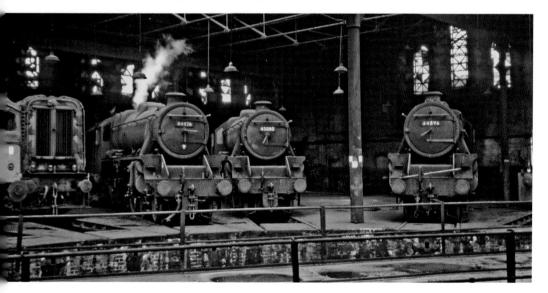

June 1967. LMS Black Five 4-6-0s 44826, 45080, 44896 inside Holbeck MPD, Leeds.
Three Stanier Black Five 4-6-0s 44826, 45080 and 44896 appear to be huddling together to protect themselves from the ever-encroaching threat of diesel power on both sides. All three had been loyal long-term servants to Leeds depots and had congregated at Holbeck for one last year of activity. With the closure of the depot to steam on 1 October 1967 these three locomotives were consigned to the scrapyard.

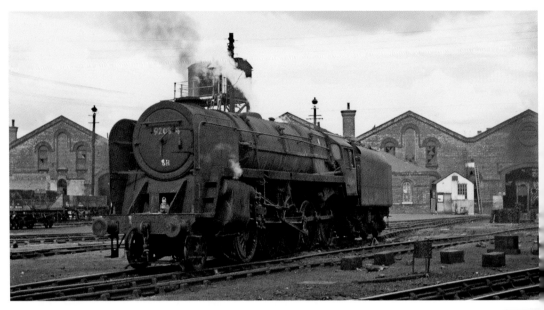

July 1967. BR standard 9F 2-10-0 92054, Holbeck MPD, Leeds.
BR standard 9F 2-10-0 92054 was built at Crewe in September 1955 and was based at a number of depots in the East Midlands before being reallocated to Speke Junction MPD in June 1964. It was to remain active working from this depot until finally being withdrawn in May 1968. It had headed an oil train into Leeds and was being serviced and turned before working an empty tank train back to Cheshire. (L. Flint)

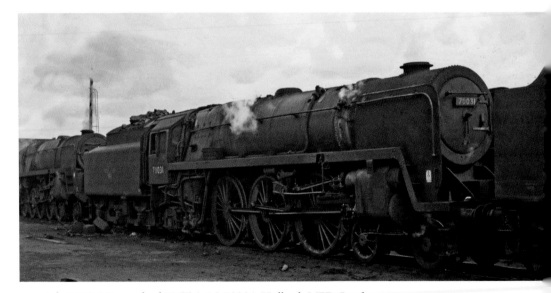

July 1967. BR standard 7MT 4-6-2 70031, Holbeck MPD, Leeds.
BR standard Britannia 7MT 4-6-2 70031 was originally named *Byron*, however its nameplates had been removed by this stage in its career. It was built at Crewe Works in November 1952 and worked from many depots throughout the old LMS system, before making its last move to Carlisle in July 1965. In common with most of Kingmoor's allocation of the class it would not see the year out, being withdrawn in November 1967. (L. Flint)

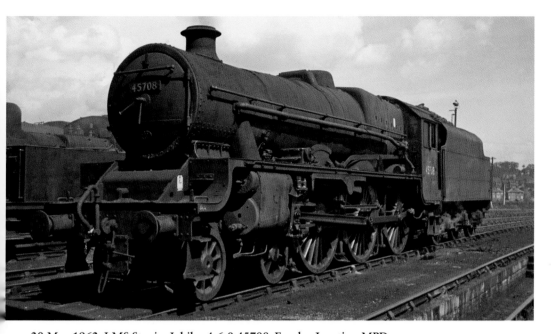

20 May 1962. LMS Stanier Jubilee 4-6-0 45708, Farnley Junction MPD.
LMS Stanier Jubilee 4-6-0 45708 *Resolution* was built at Crewe Works in June 1936 and had been a Farnley Junction-allocated locomotive throughout its British Railways career. It was resident at Farnley in January 1948 and was still there when it was finally withdrawn in March 1963.

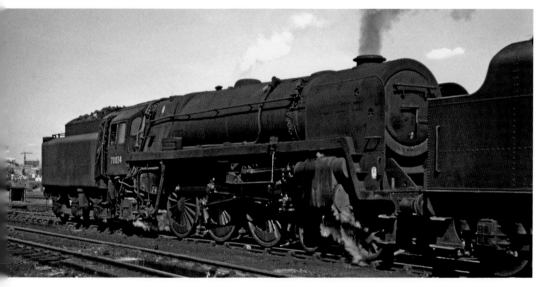

June 1966. BR standard Britannia 7MT 4-6-2 70034, Farnley Junction MPD.
BR standard Britannia 7MT 4-6-2 70034 was originally named *Thomas Hardy*. It was built at Crewe Works and entered service in December 1952, soon working on the Great Eastern section before reallocation to Willesden in March 1963. At the time it was seen at Farnley Junction it had become yet another Carlisle Kingmoor-allocated Britannia. It had lost its nameplates and smokebox number and was to be withdrawn a year later in May 1967.

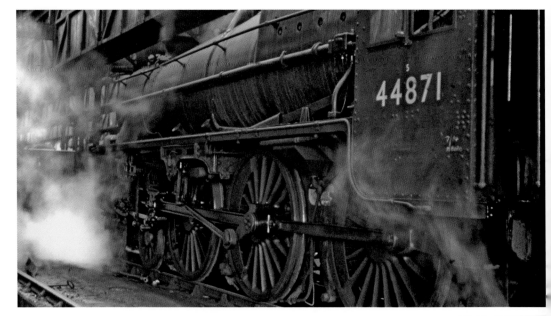

March 1966. LMS Black 5 4-6-0 44871 inside Farnley Junction MPD.
LMS Black 5 4-6-0 44871 was built at Crewe in March 1945. During its career it had been allocated to many depots throughout the LMS system. It was seen in Farnley Junction MPD in remarkably good external condition having emerged from Crewe Works in late January 1966. Typical of the period, it had been repainted in plain black with no mixed traffic lining. It was allocated to Stockport Edgeley at the time and would go on to fame and glory in August 1968 when it worked, with other locos, the 15 Guinea Special at the end of steam operations by British Railways. It was later purchased privately for preservation and remains a regular and popular performer on the main line and several heritage railways.

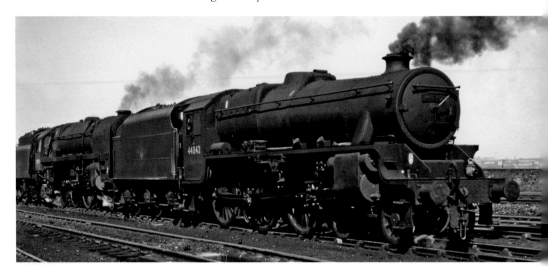

June 1966. LMS Black 5 4-6-0 44842 with 70034, Farnley MPD.
LMS Black 5 4-6-0 44842 was built at Crewe in October 1944 and during its career served at twelve different depots. At the time of the photograph it was allocated to Springs Bank, Wigan. It was finally withdrawn from service at Stockport Edgeley MPD in January 1968.

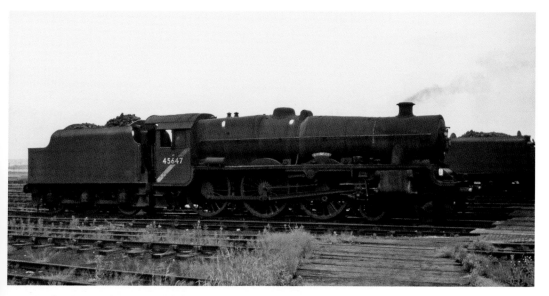

9 July 1966. LMS Stanier Jubilee 4-6-0 45647, Farnley Junction MPD.
LMS Stanier Jubilee 4-6-0 45647 *Sturdee* was built at Crewe Works in January 1935 and had served at many depots in the LMS territory before reallocation to Farnley Junction MPD in February 1964. It was to be transferred to Holbeck MPD in December 1966 and was one of five of the class to operate from there in 1967. It was the first of that illustrious group to be withdrawn at the end April and was then stored at Wakefield MPD until August 1967, after which it was removed for scrapping at Cashmore's of Great Bridge.

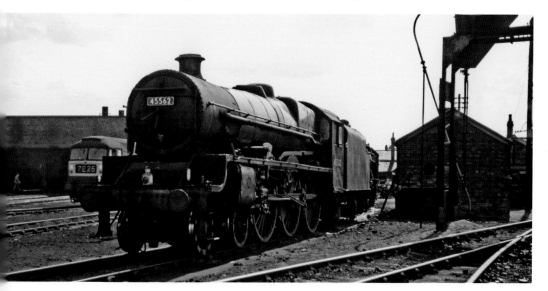

September 1966. LMS Stanier Jubilee 4-6-0 45562, Farnley Junction MPD.
LMS Stanier Jubilee 4-6-0 45562 *Alberta* had been a Holbeck-allocated locomotive since January 1948 but had moved to Farnley Junction in March 1964. It was nearing the end of its stay at Farnley and by the beginning of 1967 it would be a Holbeck locomotive once again. It was already beginning to receive special treatment with the unusual background to the smokebox number.

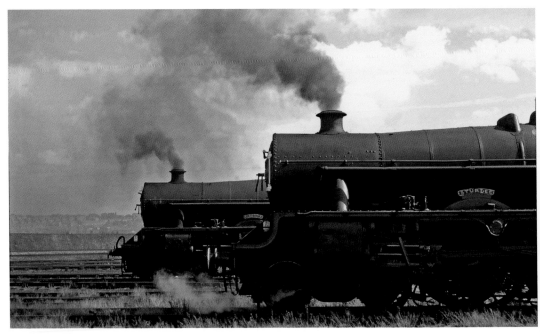

September 1966. LMS Stanier Jubilee 4-6-0s 45647 and 45562, Farnley Junction MPD.
LMS Stanier Jubilee 4-6-0 45647 *Sturdee* keeps company with 45562 *Alberta* as they raise steam together and prepare for their next duty outside Farnley Junction MPD. Both locomotives would be called upon for one final season of service in 1967 working from Holbeck MPD.

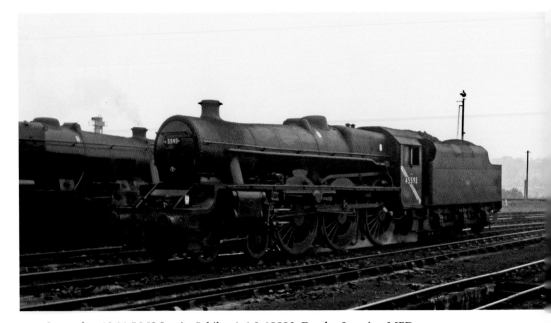

September 1966. LMS Stanier Jubilee 4-6-0 45593, Farnley Junction MPD.
LMS Stanier Jubilee 4-6-0 45593 *Kolhapur* and a nicely cleaned 8F stand together in the yard at Farnley Junction MPD. The local band of enthusiast cleaners had no doubt been busy ensuring that in the last days of steam they had some attractive-looking locomotives to photograph.

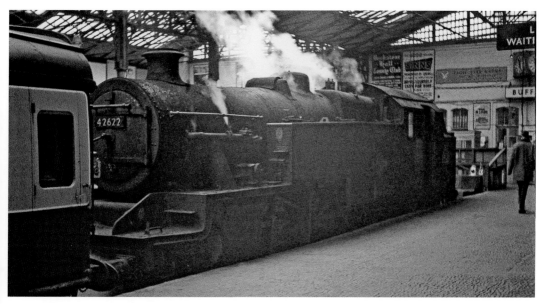

April 1965. LMS Stanier 4MT 2-6-4T 42622 arrives at Leeds Central station.
LMS Stanier 4MT 2-6-4T 42622 was built at Derby Works in July 1938. After spending much
of its early career in Lancashire it arrived in West Yorkshire in June 1956. Bradford's Low Moor
had been its home for six years as well as spells at Wakefield and Copley Hill depots. It was
allocated to Holbeck MPD in September 1964 and was finally withdrawn in February 1967.

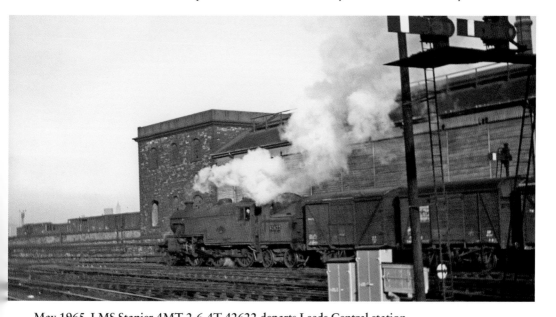

May 1965. LMS Stanier 4MT 2-6-4T 42622 departs Leeds Central station.
LMS Stanier 4MT 2-6-4T 42622 was allocated to Copley Hill MPD until that depot closed in
September 1964. The locomotive then moved to Holbeck MPD, but continued to be rostered
on duties it had previously undertaken. This meant 42622 remained a familiar sight at Leeds
Central station until its withdrawal in February 1967. The station itself only lasted a short time
after the demise of 42622, closing its doors at the end of April 1967.

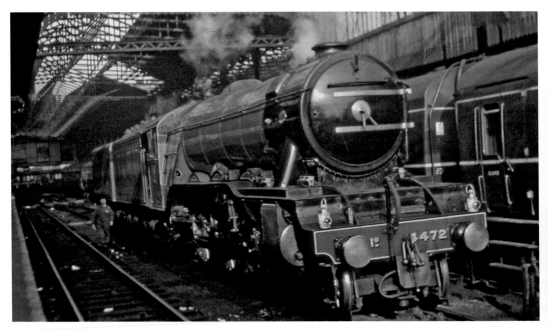

16 April 1967. LNER A3 4-6-2 4472 in Leeds Central station.
LNER A3 4-6-2 4472 *Flying Scotsman* was withdrawn from service in January 1963, and bought by Alan Pegler soon afterwards. It was overhauled and repainted at the Plant Works, Doncaster, where it also received a second tender for extra water supplies. It began hauling rail tours and specials in 1963 until it was transported to the USA in 1969. It was photographed at Leeds Central station as it waited for the arrival of the Epsom Railway Society's 'LNER Preservation Tour', which it would haul down to Kings Cross, London.

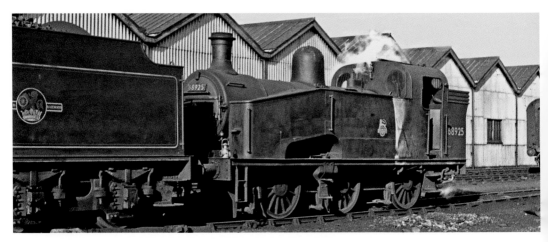

21 February 1960. LNER J50/2 0-6-0T 68925, Copley Hill MPD.
LNER J50/2 0-6-0T 68925 was built for the Great Northern Railway at Doncaster Plant in December 1922. It was allocated from new to Ardsley MPD, which was the spiritual home for the class and the reason they were commonly referred to as 'Ardsley tanks'. After more than twenty-five years working from Ardsley it was transferred to Copley Hill MPD in 1948, where it remained until being withdrawn in March 1963. It found its way to Doncaster Plant after withdrawal but was not scrapped until well into 1964.

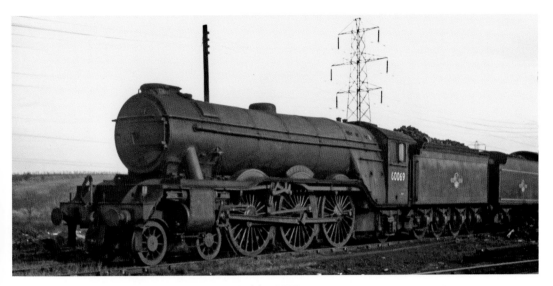

October 1962. LNER A3 4-6-2 60069, Ardsley MPD.
LNER Gresley A3 4-6-2 60069 *Sceptre* was built by the North British Locomotive Company in September 1924. It had been a North Eastern-allocated locomotive for most of its career working from Gateshead, Heaton and York. It became a resident of Copley Hill in June 1960 before its final move to Ardsley MPD in June 1961. It was fitted with a double chimney in 1959 but retained its original dome cover. It was seen looking presentable and fully coaled, but had already been withdrawn early in October 1962. It remained stored at Ardsley until May 1963, when it was removed to Doncaster Plant for scrapping.

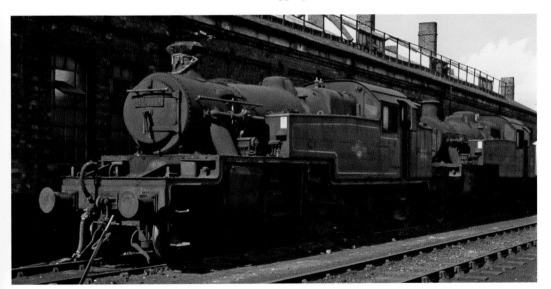

12 August 1963. LMS Stanier 3MT 2-6-2T 40112 , Ardsley MPD.
LMS Stanier 3MT 2-6-2T 40112 was built at Derby Works in July 1935 and became a West Yorkshire resident in October 1953 when it was allocated to Bradford Manningham shed. Its final move came in February 1957, when it found a new home at Copley Hill MPD from where it was withdrawn in November 1962. It was seen stored at Ardsley MPD along with classmate 40114 before removal to Darlington Works for scrapping.

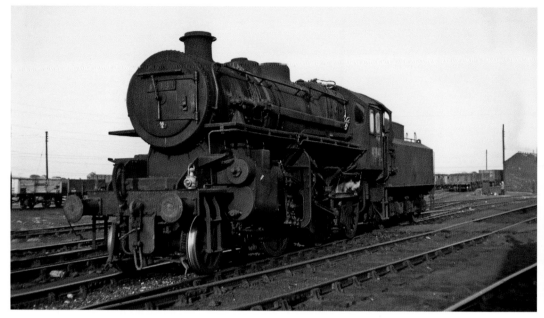

29 June 1965. LMS Ivatt 4MT 2-6-0 43141, Ardsley MPD.
LMS Ivatt 4MT 2-6-0 43141 was built at Doncaster Plant in August 1951 and was first allocated
to Scotland. It eventually found its way to West Yorkshire in June 1964 when it was reallocated
to Low Moor, Bradford. Its next move was to Ardsley MPD in November 1964 and then its final
home became Normanton a year later. It was withdrawn from Normanton in October 1966.

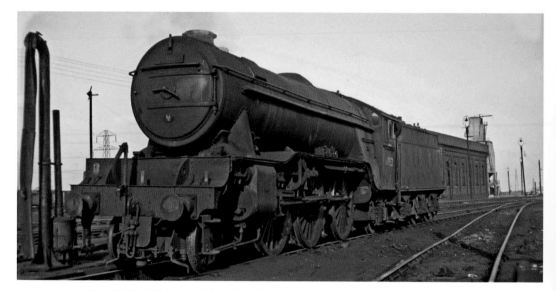

29 June 1965. LNER V2 2-6-2 60923, Ardsley MPD.
LNER V2 2-6-2 60923 was a product of Darlington Works in November 1941 and had spent its
working life in the North East until December 1962, when it was reallocated to Ardsley MPD.
It received a general overhaul at Darlington Works in February 1964 but in less than two years
was to be withdrawn from Ardsley in October 1965. It spent time in store at Wakefield MPD
before it was eventually cut up by Cashmore's of Great Bridge in 1966.

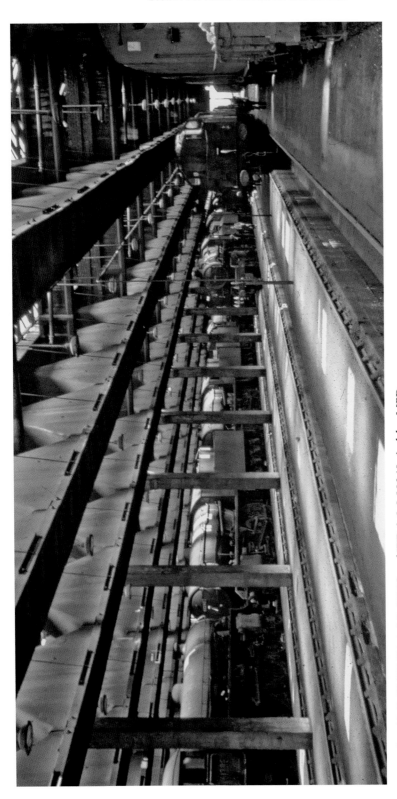

September 1965. LNER B1 4-6-0 61238 and WD 2-8-0 90240, Ardsley MPD.
Stored locomotives quietly await their fate inside Ardsley MPD. The sunlight coming through the roof lights emphasises the unusual cleanliness of the shed. All the clutter of a working depot has been removed, only the steam locomotives remained. Two locos visible on the left row, LNER B1 4-6-0 61238 and WD 2-8-0 90240, were to have a short active life after this scene. 61238 *Leslie Runciman* had spent its career in the North East before reallocation to Ardsley in June 1964. It was to be reallocated to York in October 1965, being withdrawn from service in February 1967. 90240 was another loco reallocated to Ardsley from the North East, arriving there in June 1962. It was to move to Hull Dairycoates in November 1965 before being withdrawn in January 1967.

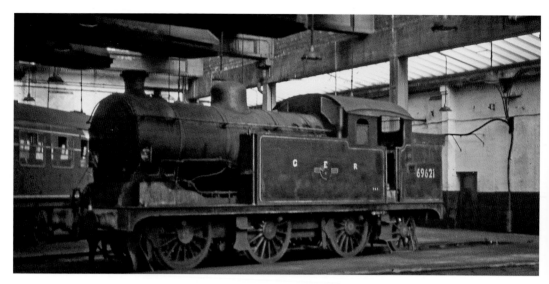

April 1964. LNER N7 0-6-2T 69621 inside Neville Hill MPD.
LNER N7 0-6-2T 69621 was built at Stratford Works in March 1924. It was the last of the
original batch of twenty-two locomotives and was the last engine to be built at Stratford Works.
It spent the majority of its working life hauling commuter trains to and from London's Liverpool
Street station. In September 1962 it was withdrawn from Stratford depot and was purchased
for preservation by Dr Fred Youell. He had connections with the Middleton Railway in Leeds,
and the locomotive was stored in Neville Hill MPD for around ten years before moving to East
Anglian Railway Museum. It was eventually restored to working order in 1989.

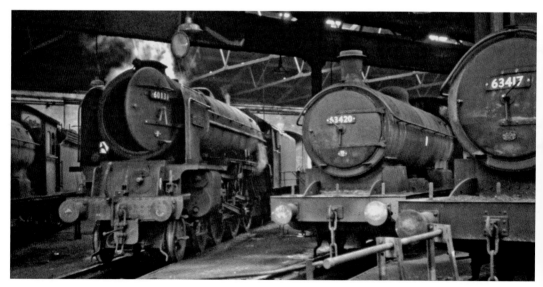

May 1965. LNER A1 4-6-2 60131 with Class Q6 0-8-0s 63420 and 63417, Neville Hill MPD.
LNER A1 4-6-2 60131 *Osprey* was built at Darlington Works in October 1948. It become a
Leeds-based locomotive in February 1953 when it was allocated to Copley Hill MPD. It was
to spend fifteen months at Ardsley depot before arriving at Neville Hill in August 1963. It
was seen inside the roundhouse keeping company with three LNER Q6 0-8-0s, including 63420
and 63417.

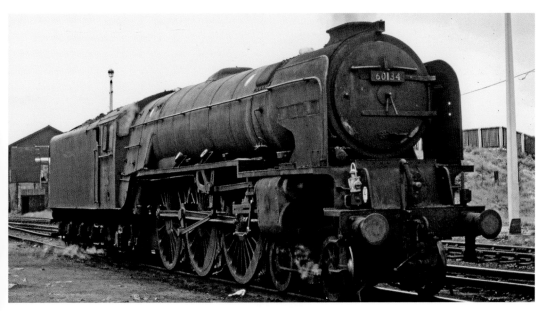

May 1965. LNER A1 4-6-2 60134, Neville Hill MPD.
LNER A1 4-6-2 60134 *Foxhunter* was built at Darlington Works in November 1948. It had always been based in West Yorkshire; its first allocation was to Copley Hill, where it stayed until May 1962 before being transferred to Ardsley MPD. Its final move came in August 1963 to Neville Hill, from where it would be withdrawn in October 1965. It was scrapped by T. W. Ward of Beighton at the end of 1965.

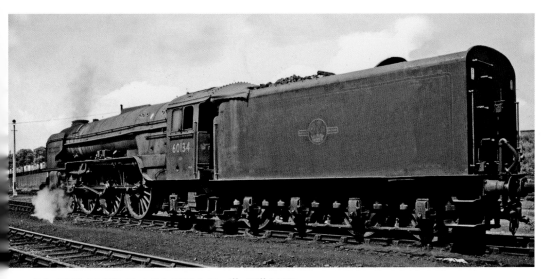

July 1965. LNER A1 4-6-2 60134, Neville Hill MPD.
LNER A1 4-6-2 60134 *Foxhunter* was regularly seen working down the East Coast Main Line at the head of one of the several Pullman trains to run between Leeds and London. The 'Queen of Scots', 'The Harrogate Sunday Pullman' and the 'Yorkshire Pullman' have all been in the capable hands of this A1. By the time this photograph was taken diesels had taken over all of these duties and the A1s were left with very little work. Dirty and neglected within a couple of months, 60134 was to be withdrawn.

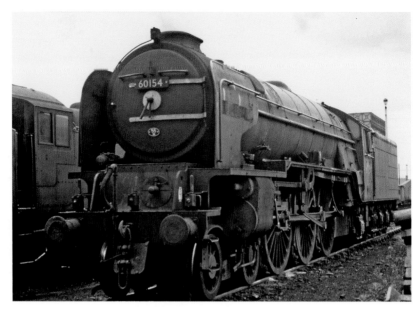

May 1965. LNER A1 4-6-2 60154, Neville Hill MPD.
LNER A1 4-6-2 60154 *Bon Accord* was built at Doncaster Plant in September 1949. It spent eleven years at Gateshead depot before being reallocated to York for three years. It arrived on Neville Hill's books in July 1963 and was withdrawn from service, along with the depot's other three A1s, in October 1965. Along with its classmates it was scrapped by T. W. Ward of Beighton towards the end of the year.

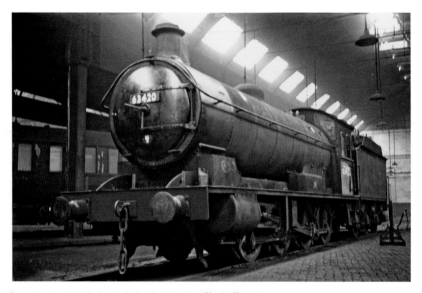

September 1965. LNER Q6 0-8-0 63420, Neville Hill MPD.
LNER Q6 0-8-0 63420 was built by Armstrong Whitworth of Newcastle in March 1920. It spent forty-two years working in the North East of England before finding its way to Neville Hill in December 1962. In June 1966 it moved for a short stay at Normanton MPD, but by October it was back onto the more familiar territory of Tyne Dock. It was eventually withdrawn from Tyne Dock in February 1967.

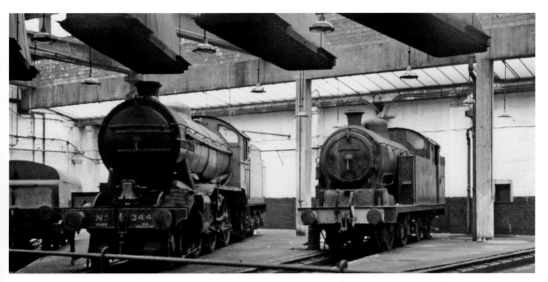

25 November 1967. LNER K4 2-6-0 3442 and N7 0-6-2T 69621 inside Neville Hill MPD.
LNER N7 0-6-2T 69621 was purchased for preservation by Dr Fred Youell and found a home at Neville Hill in late 1962. LNER K4 2-6-0 3442 *The Great Marquess* (61994) was withdrawn from service by British Railways in December 1961. It was purchased by Viscount Garnock and overhauled at Cowlairs Works in 1963. It then moved to Neville Hill depot in April 1963 and regularly worked steam specials until boiler problems put an end to its activities in April 1967. It remained stored at the depot until September 1972, when it was moved to the Severn Valley Railway. It has since had an active career on the national network and on several preserved lines.

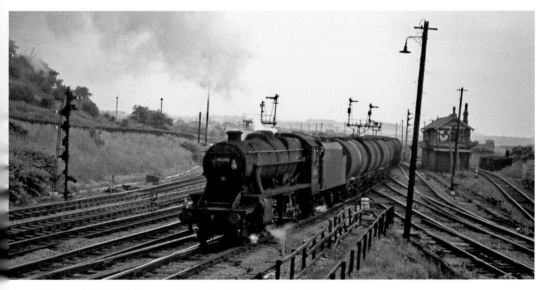

26 June 1968. LMS Stanier 8F 2-8-0 48393 at Neville Hill.
LMS Stanier 8F 2-8-0 48393 was built at Horwich in April 1944 and spent most of its career working from depots in the East Midlands. It was transferred over the Pennines to Lostock Hall in November 1966, with its final move to Rose Grove in June 1967. It was one of the last working steam locomotives when withdrawn on 3 August 1968. It was seen at Neville Hill with an oil train empties about to return over the Pennines.

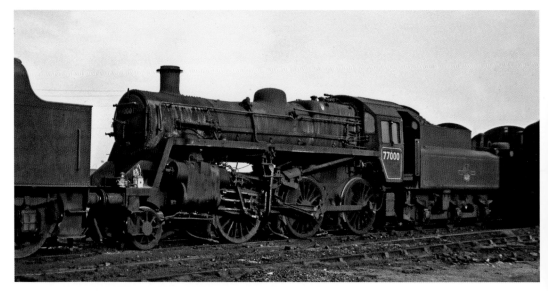

28 March 1965. BR standard 3MT 2-6-0 77000, Stourton MPD.
BR standard 3MT 2-6-0 77000 was built at Swindon Works in February 1954 and spent much of its working life based at all three Hull depots at different times. In January 1963 it was transferred to Darlington before finding its way to Stourton MPD in June 1964. The depot became the final home for a number of this small and somewhat elusive class of locomotives. 77000 was eventually withdrawn from service in December 1966.

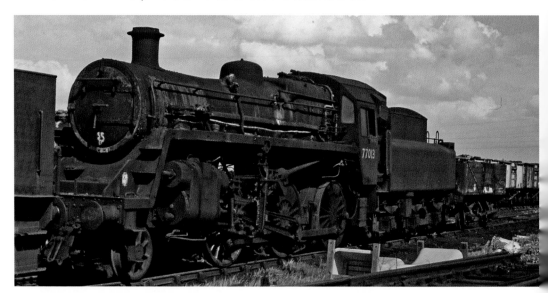

April 1966. BR standard 3MT 2-6-0 77013 stored at Stourton MPD.
BR standard 3MT 2-6-0 77013 was one of a class of twenty standard locomotives built at Swindon Works. 77013 was released into traffic in July 1954 and had a fairly nomadic career around depots in the North Eastern Region, with stays at Darlington, Whitby, Selby, Scarborough and York. Stourton MPD became a magnet for several of the class in their last few years of service. 77013 was transferred there in September 1963 and withdrawn in March 1966, being scrapped by T. W. Ward of Beighton later that year.

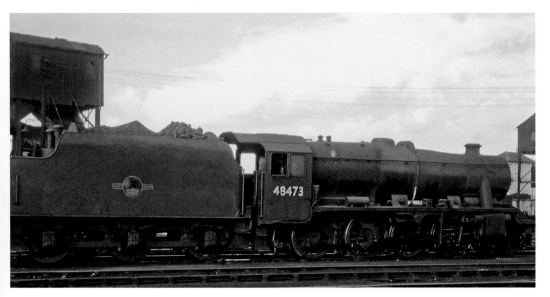

November 1967. LMS Stanier 8F 2-8-0 48473 on Stourton MPD.
LMS Stanier 8F 2-8-0 48473 was built at Swindon Works in April 1945, and after working from various depots around the network it settled in West Yorkshire in September 1951 at Royston MPD. It had one reallocation in March 1965 to Stourton MPD before heading back to Royston in November 1966 for its final year of active service. The larger numerals on the cab side denote that the locomotive's last general overhaul was at Darlington, which had become the works dealing with many of the class towards the end of steam.

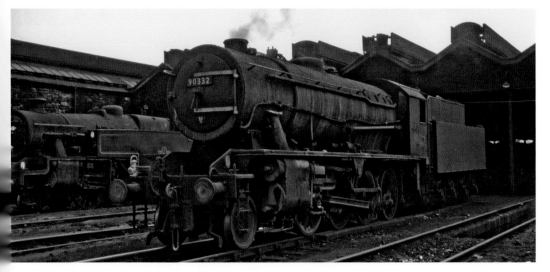

July 1964. WD 2-8-0 90332 at Hillhouse MPD, Huddersfield.
WD 2-8-0 90332 was built by the North British Locomotive Company in June 1944 for the Ministry of Supply and numbered 70853. After spending time in Belgium it was transferred to France to work on the SNCF. It was repatriated to England in 1947 and later bought by British Railways. It had been a Huddersfield Hillhouse locomotive from May 1950 until the shed closed in January 1967 when it was transferred to Normanton. It was withdrawn a few months later in March 1967 and scrapped by T. W. Ward at Killamarsh.

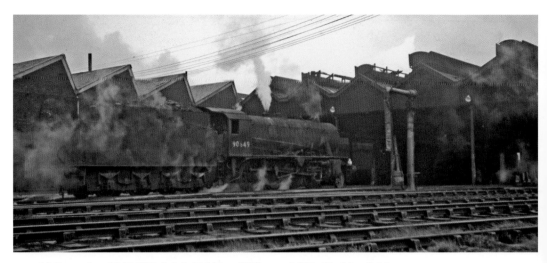

28 December 1966. WD 2-8-0 90649 at Hillhouse MPD, Huddersfield.
WD 2-8-0 90649 was produced by the Vulcan Foundry in July 1944 and worked on the SNCF in France. It returned to England in 1947 and was eventually purchased for use on British Railways. It was allocated to Farnley Junction MPD in March 1950 and then moved to Huddersfield in July 1959. When the shed closed in January 1966 it was transferred to Royston but was quickly withdrawn and scrapped by Draper's of Hull.

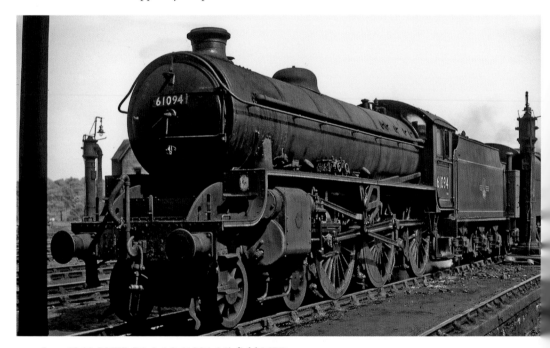

June 1964. LNER B1 4-6-0 61094, Mirfield MPD.
LNER B1 4-6-0 61094 was built by the North British Locomotive Company in November 1946 for the LNER. Its first allocation was to Doncaster MPD; it then worked from Hitchin depot for ten years before moving to Darnall in August 1959. It was a Canklow-based locomotive when photographed at Mirfield MPD. It had twelve more months of service remaining before it made its way to T. W. Ward of Sheffield for scrapping.

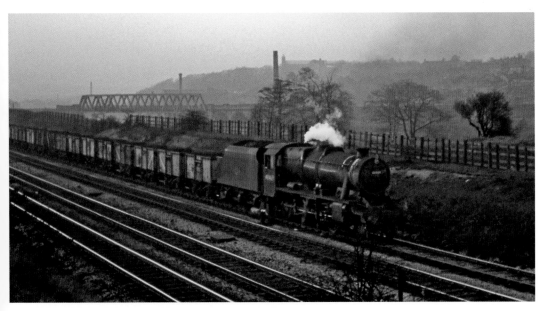

April 1965. LMS Stanier 8F 2-8-0 48469, near Mirfield.
LMS Stanier 8F 2-8-0 48469 was built at Swindon in March 1945 and spent its career working from depots either side of the Pennines, including eleven years at Royston MPD. At the time of the photograph the loco had just been reallocated to Bolton and had received a general overhaul at Darlington Works a couple of months earlier. This accounts for its relatively clean condition. (L. Flint)

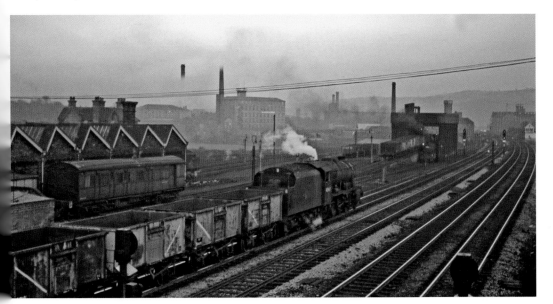

April 1965. LMS Stanier 8F 2-8-0 48469 passes Mirfield MPD.
From Woodend Lane Bridge the camera follows LMS Stanier 8F 2-8-0 48469 as it trundles a long string of coal empties passed Mirfield MPD. The very recognisable shed wall, water tank and coaling facility are all clearly visible along with the wool mills and their chimneys, which were so synonymous with the area. (L. Flint)

April 1965. BR standard 9F 2-10-0 92118 at Mirfield MPD.
BR standard 9F 2-10-0 92118 was built at Crewe in December 1956 and worked from a number of depots in the East and West Midlands. At the time that it was caught on camera at Mirfield MPD it was a Tyseley locomotive. It was to be reallocated once more in November 1966 to Carnforth, where it was withdrawn in May 1968 and scrapped at T. W. Ward of Beighton in September of that year. The couple in the garden were busy with spring planting in their allotment-sized plot, oblivious to the everyday occurrence of a steam locomotive being turned a short distance from them. (L. Flint)

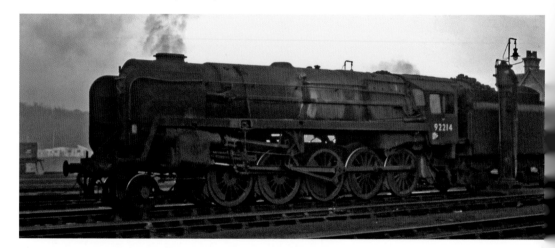

April 1965. BR standard 9F 2-10-0 92214, Mirfield MPD.
BR standard 9F 2-10-0 92214 was a Swindon-built locomotive and entered service in October 1959. After two years based at Banbury MPD it moved to Wales, eventually being reallocated to Severn Tunnel Junction depot in July 1964. Less than four months after its visit to Mirfield MPD it was withdrawn having had a working life of six years and nine months. By February 1966 it had been sold for scrap and found its way to Woodham Brothers of Barry. It was bought for preservation in December 1980 and moved to Buxton. Ten years later it was sold again and finally restored to working condition at Butterley in 2003. It now operates on the Great Central Railway at Loughborough. (L. Flint)

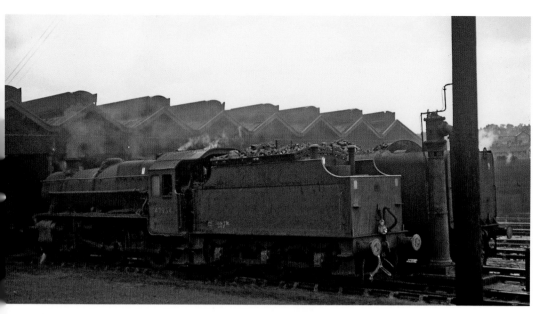

7 August 1965. Stanier 2-6-0 5P6F 42964, Mirfield MPD.
Stanier 2-6-0 5P6F 42964 was built at Crewe in January 1934, a member of the first class of locomotives William Stanier designed for the LMS. 42964 led a nomadic existence being reallocated to at least twenty-five depots, mainly in the North West, during its thirty-year career. In May 1965 it made its last move to Heaton Mersey MPD from where it was withdrawn in October of that year.

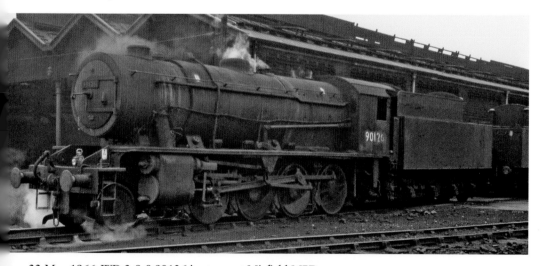

22 May 1966. WD 2-8-0 90126 in steam at Mirfield MPD.
WD 2-8-0 90126 was built by the North British Locomotive Company in April 1943 for the Ministry of Supply and numbered 77029. It was initially loaned to the LNER, but by 1945 it had been shipped to France to work on the SNCF. It came back to England in 1947 and was stored at Kingham to await overhaul. It entered service with British Railways in March 1949, working from Rose Grove MPD. By November 1956 it had been reallocated to Mirfield and was to remain a resident there more or less until July 1962, when it moved to Ardsley. It was reallocated once more in November 1965 to Wakefield and was withdrawn from there in January 1967.

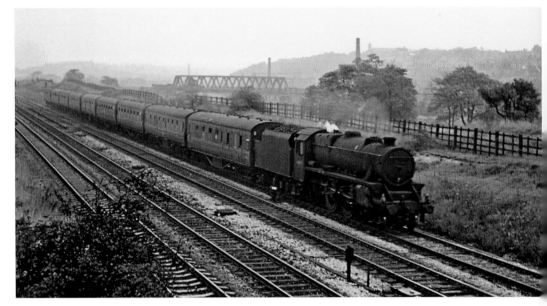

June 1966. LMS Stanier Black Five 4-6-0 45080 near Mirfield.
LMS Stanier Black Five 4-6-0 45080 was built by the Vulcan Foundry for the LMS in March 1935. It spent much of its career working from West Yorkshire depots, mainly Farnley Junction MPD, before having a few months at Stourton. It finally settled at Holbeck in January 1967 for the last ten months of active service. It was withdrawn in October 1967 and finally scrapped by T. W. Ward at Killamarsh in mid-1968.

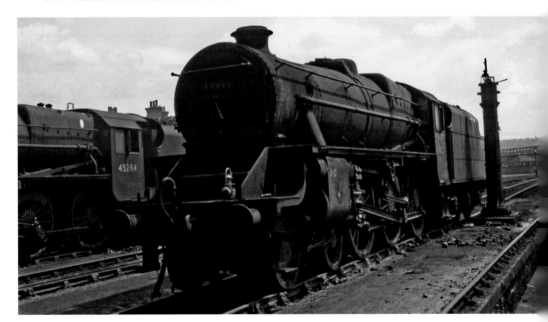

26 June 1966. LMS Black 5 4-6-0 44935, Mirfield MPD.
LMS Black 5 4-6-0 44935 was built at Horwich Works and entered service in October 1946. It worked from depots in the North West throughout its career, with its final allocation being to Warrington Dallam in April 1965. It was withdrawn from there in October 1966.

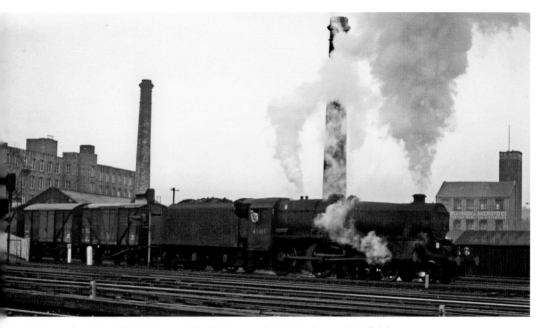

3 December 1966. LMS Stanier Black Five 4-6-0 45015 departs Mirfield.
LMS Stanier Black Five 4-6-0 45015 was built at Crewe Works in April 1935, part of the first batch of twenty Black Fives built there. Its final allocation was to Edge Hill MPD in November 1961 and it worked from there until withdrawal from service in September 1967. It was seen working through Mirfield on a fitted freight train. (L. Flint)

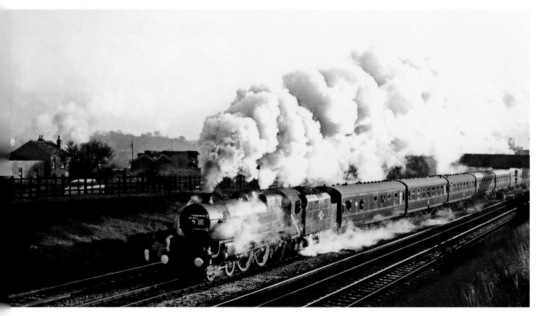

3 December 1966. LMS Stanier Jubilee 4-6-0 45593 near Mirfield.
The Jubilee Locomotive Preservation Society organised a special rail tour that left Leicester behind LMS Stanier Jubilee 4-6-0 45562 *Alberta* to Mirfield. Here a change of engines took place and Jubilee 45593 *Kolhapur* headed the train to Carlisle via Copy Pit and Shap. (L. Flint)

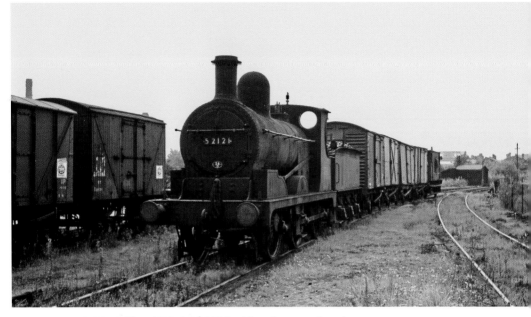

June 1962. L&Y Class 27 0-6-0 52121 with a short goods train.
L&Y Class 27 0-6-0 52121 was built by the Lancashire & Yorkshire Railway at their Horwich Works in May 1891. It had been based in West Yorkshire at a number of ex-L&Y depots before being transferred to Sowerby Bridge in March 1962. It worked mainly pilot duties at Greetland and Hebden Bridge, as well as banking up the Greetland gradient.

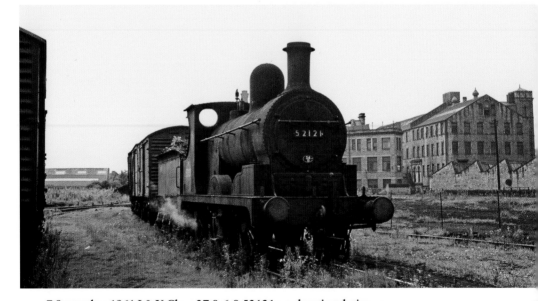

7 September 1961 L&Y Class 27 0-6-0 52121 on shunting duties.
L&Y Class 27 0-6-0 52121 was one four similar locomotives reallocated late in their career to Sowerby Bridge MPD. They performed trip freight, shunting and pilot duties in the local area. All four were withdrawn in December 1962 and scrapped shortly afterwards. They all had a remarkably long working life, with 52121 being in service for over seventy years.

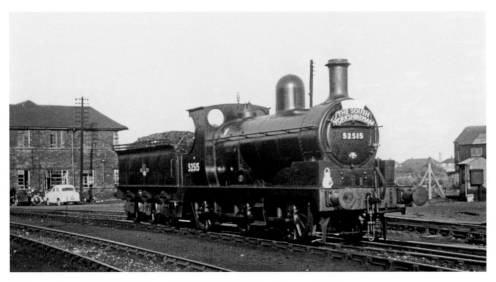

29 September 1962. L&Y Class 27 0-6-0 52515, Darlington MPD.
L&Y Class 27 0-6-0 52515 was built at Horwich Works in November 1906. It spent much of its long career in West Yorkshire and rather surprisingly received a general overhaul and repaint at Horwich in November 1961. It became one of four similar locomotives reallocated to Sowerby Bridge MPD in March 1962. It was used in September of that year to double-head an enthusiasts special with LMS 4F 0-6-0 44408, travelling from Sowerby Bridge to Doncaster and Darlington. It was seen at Darlington before the return journey. It was withdrawn from service in December 1962 along with its three classmates. (L. Flint)

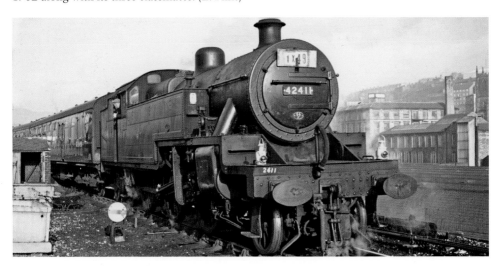

18 April 1964. LMS Fowler 4MT 2-6-4T 42411 waits at Sowerby Bridge.
LMS Fowler 4MT 2-6-4T 42411 was built at Derby in October 1933 and worked from several ex-L&Y depots in its career. Huddersfield, Goole, Mirfield and Low Moor had all been its home, as well as Sowerby Bridge. In January 1961 it moved to Copley Hill but three years later in January 1964 it was back on more familiar territory at Low Moor MPD, where it was withdrawn in August of that year. It was seen at Sowerby Bridge at the head of the Halifax Railfans and Pennine Railway Society special, which it hauled to Huddersfield on the first leg of the journey to Crewe.

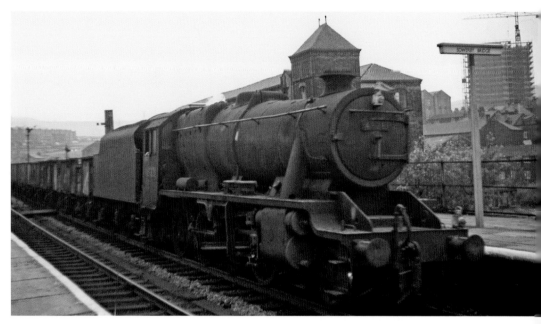

15 June 1966. LMS Stanier 8F 2-8-0 48281 trundles through Sowerby Bridge.
LMS Stanier 8F 2-8-0 48281 was built by the North British Locomotive Company for the LMS in August 1942. After spending time at Wellingborough MPD it was reallocated to Royston in September 1955 and remained faithful to that depot until withdrawal in September 1967. It was seen at the head a train of coal empties as it passed through Sowerby Bridge station.

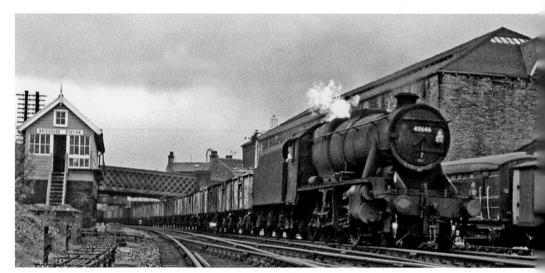

May 1966. LMS Stanier 8F 2-8-0 48646 leaves Brighouse.
LMS Stanier 8F 2-8-0 48646 was built at Brighton Works and entered service in November 1943. It spent much of its career working in the Midlands. It was based at Saltley when seen trundling through Brighouse with a long string of empties heading for the Yorkshire coalfields. One more reallocation in February 1967 would see it move to Lostock Hall, which ensured it was still active in the final weeks of steam on British Railways. It was withdrawn in May 1968 and cut up at Draper's of Hull in December of that year.

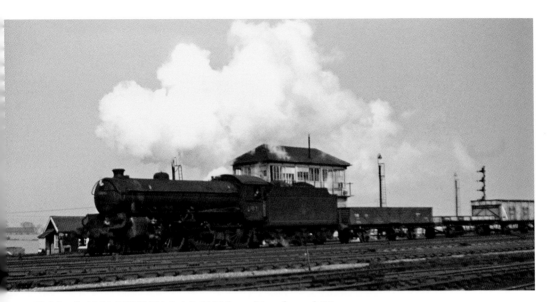

19 March 1966. LNER B1 4-6-0 61021 working through Normanton.
LNER B1 4-6-0 61021 *Reitbok* was built at Darlington Works in March 1947 and spent its working life in the North East before reallocation to York in September 1960. By the time it was seen working a mixed freight through Normanton it had lost its nameplates and it was to be withdrawn in June 1967. Its final journey was to take it back to the North East to be scrapped at Hughes Bolchow of North Blyth.

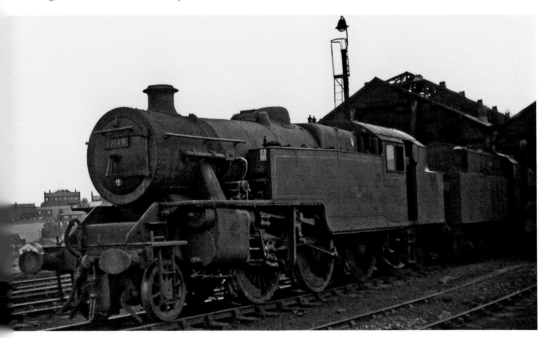

June 1966. LMS Fairburn 4MT 2-6-4T 42149, Normanton MPD.
LMS Fairburn 4MT 2-6-4T 42149 was built at Derby Works in May 1948 and spent its entire career based in West Yorkshire at Sowerby Bridge until March 1962, when it moved to Normanton MPD. It would remain on Normanton's books until withdrawn in June 1967.

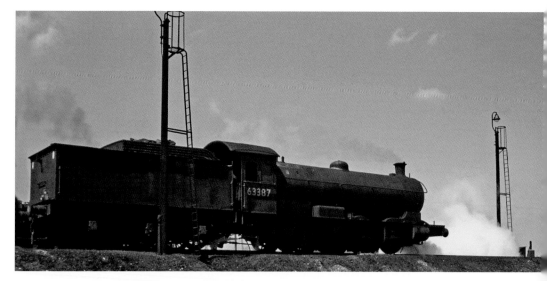

29 June 1966. LNER Q6 0-8-0 63387 in Normanton Yard.
LNER Q6 0-8-0 63387 was built by the North Eastern Railway at Darlington Works in November 1917 and spent its first ten years working from Hull Springhead depot before reallocation to more familiar territory for the class at East and West Hartlepool. In September 1941 it was back in Yorkshire for a ten-year stay at Selby MPD before it moved back to the North East in August 1951. In March 1965 it returned south with a move to Neville Hill MPD, followed by a few months at Normanton. By October 1966 it was reallocated to Tyne Dock and ended its days at West Hartlepool being withdrawn in September 1967.

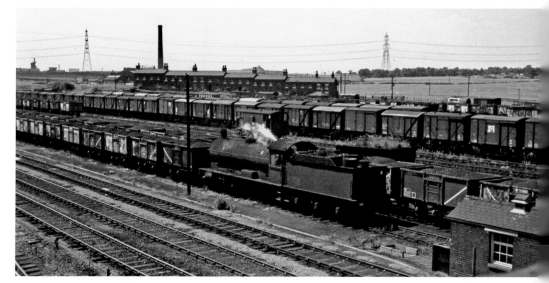

29 June 1966. LNER Q6 0-8-0 63344, Normanton Yard.
LNER Q6 0-8-0 63344 was a product of Darlington Works for the North Eastern Railway, entering service in February 1913. It spent most of its working life at various depots in the North East before reallocation in June 1964 took it to Neville Hill MPD. Along with that depot's other Q6s, it moved to Normanton in June 1966 for a short but active stay. It was back in the North East by October 1966 and was withdrawn from West Hartlepool in September 1967.

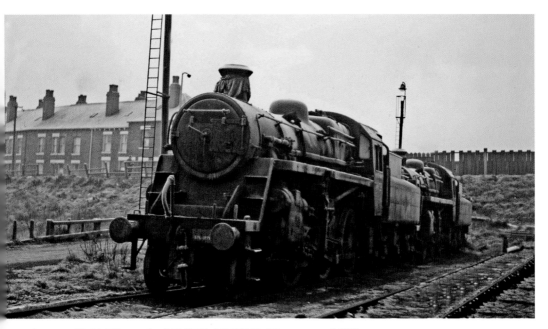

January 1967. BR standard 3MT 2-6-0 77003, Normanton MPD.
BR standard 3MT 2-6-0 77003 was built at Swindon in February 1954. It spent ten years at West Auckland MPD before moving to Stourton in February 1964; from here it was withdrawn in December 1967, being stored at Normanton. This freezing cold January day had a definite feel of *Snowdrift at Bleath Gill*, only without the snow. (L. Flint)

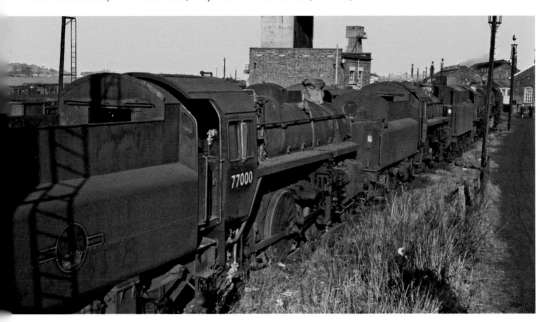

19 February 1967. BR standard 3MT 2-6-0s 77000 with 77003, Normanton MPD.
BR standard 3MT 2-6-0s 77000 with 77003 keep each other company; a pair of withdrawn WD 2-8-0s at Normanton MPD. Within a few weeks they were to make their final journey to T. W. Ward at Beighton.

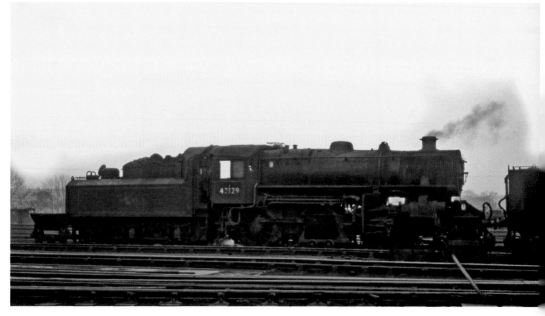

19 February 1967. LMS Ivatt 4MT 2-6-0 43129, Normanton MPD.
LMS Ivatt 4MT 2-6-0 43129 was built at Horwich and commenced its service under the new
British Railways in October 1951. It spent most of its working life in the North East at Heaton
MPD and then in July 1957 at Darlington. It was reallocated to Normanton in March 1966 and
was withdrawn from there in July 1967. (L. Flint)

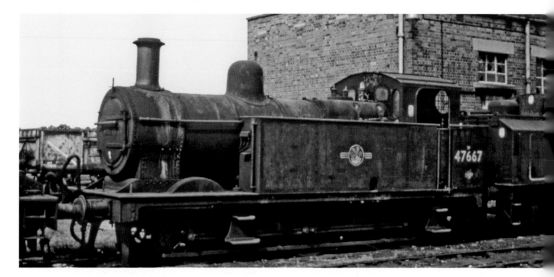

9 April 1967. LMS Fowler Jinty 0-6-0T 47667, Normanton MPD.
LMS Fowler Jinty 0-6-0T 47667 was a product of Horwich Works in April 1931. It was allocated
to Camden MPD for many years and then it moved to Carlisle in April 1958. It made its home
at both Kingmoor and Upperby before its final move came in October 1966 to Skipton MPD.
It was withdrawn the following month in November 1966. April 1967 found it stored in the
company of other withdrawn locomotives at Normanton MPD until it was towed to T. W. Ward
at Killamarsh and scrapped in the summer of 1969.

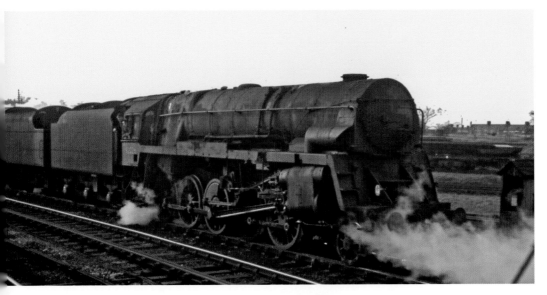

June 1967. BR standard 9F 2-10-0 92026, Normanton MPD.
BR standard 9F 2-10-0 92026 was built at Crewe in June 1955. It was one of ten 9Fs, which were fitted with a Franco-Crosti pre-heater boiler. It became one of the first of the ten similar locomotives to be converted in September 1959 to a more conventional boiler arrangement with the pre-heater removed. It continued to work from Midland area depots until October 1964, when it moved to Newton Heath. Six months later it moved again to Birkenhead Mollington Street MPD, from where it was withdrawn in November 1967.

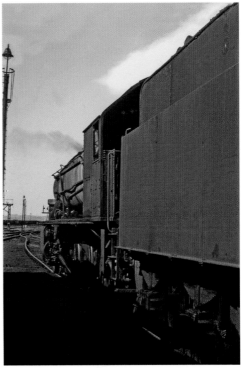

June 1967. WD 2-8-0 90699, Normanton MPD.
WD 2-8-0 90699 was a product of the Vulcan Foundry for the War Department in January 1945. It was sent to work on the SNCF in France and returned to England in 1947. It commenced its service with British Railways in February 1950 at Farnley Junction MPD and was transferred to Normanton MPD in April 1964. It was withdrawn from service in September 1967 and scrapped by Draper's in Hull.

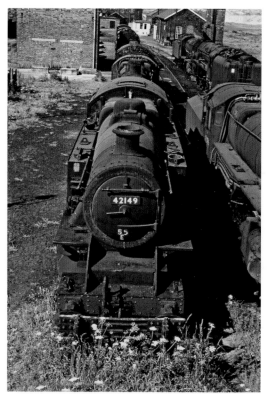

June 1967. LMS Fairburn 4MT 2-6-4T 42149, Normanton MPD.
LMS Fairburn 4MT 2-6-4T 42149 spent the last five years of its active service working from Normanton MPD but it was withdrawn a short time before the photograph. It was left in the sidings, where many locomotives resided before their final journey to the scrapyard – in the case of 42149, a somewhat delayed one. In July 1967 it moved to Wakefield MPD and another period in store before it finally arrived at Cashmore's of Great Bridge in December of that year and was broken up in early 1968.

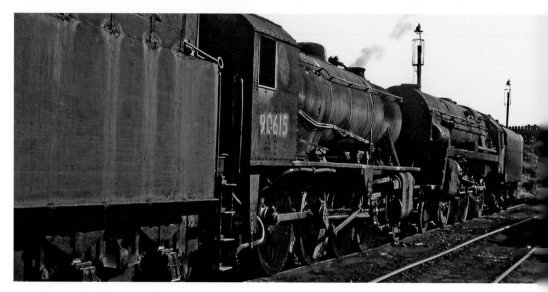

June 1967. WD 2-8-0 90615 with standard 9F 2-10-0 92026, Normanton MPD.
WD 2-8-0 90699 was built by the Vulcan Foundry for the War Department in January 1944. It worked on the SNCF and returned to England in 1947. After a period of storage and an overhaul it was allocated to Wakefield in September 1950. It moved to Royston depot in July 1966 and finally to Normanton in February 1967. After withdrawal in September 1967 it was scrapped by Arnott Young of Parkgate.

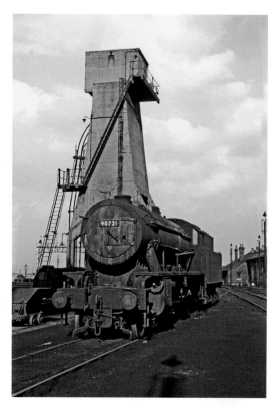

**June 1967. WD 2-8-0 90721,
Normanton MPD.**
WD 2-8-0 90721 was completed by Vulcan
Foundry in March 1945 and spent time
working on the SNCF in France before
returning to England in 1947. It entered British
Railways service in September 1950 and was
based in West Yorkshire throughout its career.
It was resident at Mirfield, Low Moor and
Wakefield before arriving at Normanton MPD
in October 1966. It was withdrawn from there
in September 1967.

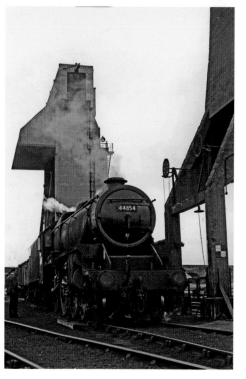

**1 August 1967. LMS Stanier Black Five 4-6-0
44854, Normanton MPD.**
LMS Stanier Black Five 4-6-0 44854 was built
at Crewe Works in December 1944 and spent
almost all its British Railways career based at
Holbeck MPD. It moved to Normanton MPD
in September 1967 after Holbeck had closed
to steam. Its stay at Normanton was to be
short, being withdrawn in October 1967. After
a period in store it departed to T. W. Ward's
of Killamarsh for cutting up in early 1968.
(L. Flint)

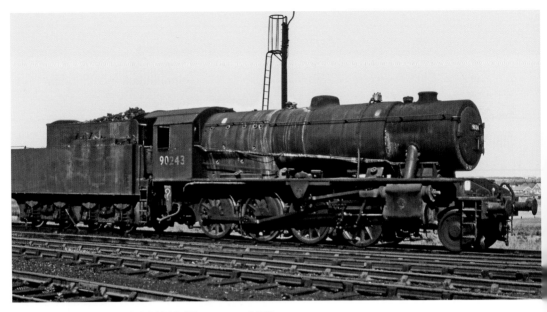

June 1967. WD 2-8-0 90243, Normanton MPD.
In the summer of 1967 there was still a good variety of steam classes on Normanton MPD, by then classified as 55E. Most of them had been transferred in from depots that had closed their doors to steam. A lot of the ex-LMS designs had already gone, but WD 2-8-0s were there in numbers along with LMS 4MT 2-6-4Ts. WD 2-8-0 90243 had been a longer term resident at the shed but would be withdrawn within days of this photograph.

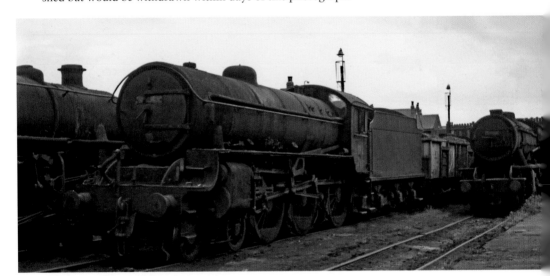

1 August 1967. LNER B1 4-6-0 61012, Normanton MPD.
LNER B1 4-6-0 61012 *Puku* was constructed at Darlington Works and entered service at Gateshead depot in November 1946. It was transferred to Hull Dairycoates MPD in July 1960 and worked from there until being transferred to York MPD in December 1966. It was withdrawn in June 1967 and found its way to storage at Normanton MPD, losing its chimney at some point. By September it had returned to the North East for the last time and scrapped at the yard of Hughes Bolchow in North Blyth. (L. Flint)

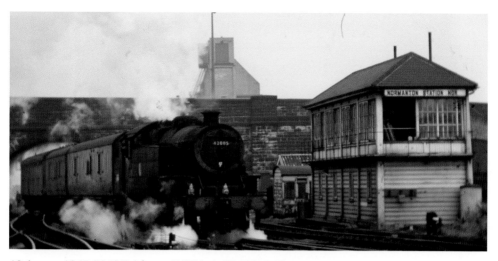

10 August 1967. LMS Fairburn 4MT 2-6-4T 42085, Normanton.
LMS Fairburn 4MT 2-6-4T 42085 emerged from Brighton Works in February 1951 and was initially based at Stewart's Lane on the Southern Region. In March 1952 it was transferred to the North Eastern Region and served at a number of depots including Heaton, Darlington, Whitby, Scarborough and York. It became a West Yorkshire locomotive in October 1965 with a move to Bradford Manningham depot.

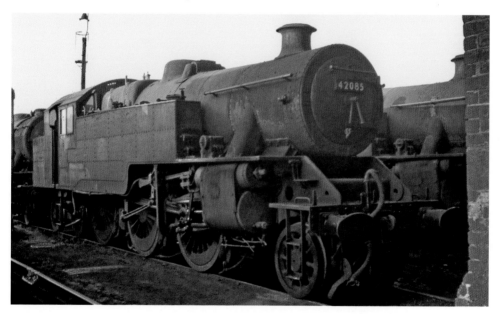

September 1967. LMS Fairburn 4MT 2-6-4T 42085, Normanton MPD.
LMS Fairburn 4MT 2-6-4T 42085 was transferred to Normanton MPD on the closure of Bradford Manningham depot in April 1967; it was withdrawn in October of that year. It joined the rows of redundant steam locomotives at Normanton awaiting disposal and was purchased by the Lakeside Railway Estates Company along with sister locomotive 42073. They were removed from Normanton and found a temporary home at Carnforth where restoration began. They were transferred to the newly formed Lakeside & Haverthwaite Railway and hauled the first train there in 1973.

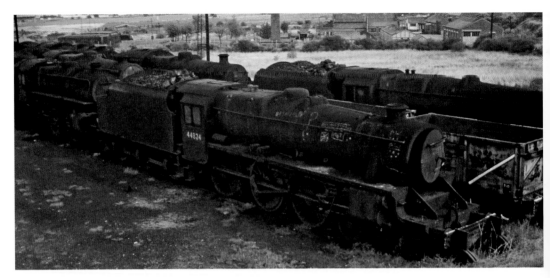

25 October 1967. LMS Stanier Black Five 4-6-0 44824, Normanton MPD.
LMS Stanier Black Five 4-6-0 44824 was built at Derby Works in December 1944. It spent much of its working life in West Yorkshire mainly at Holbeck MPD, but also at Wakefield, Farnley Junction and Low Moor. It was withdrawn from Holbeck in October 1967 and in common with many local withdrawn locomotives was stored at Normanton before making its final journey to T. W. Ward's at Beighton.

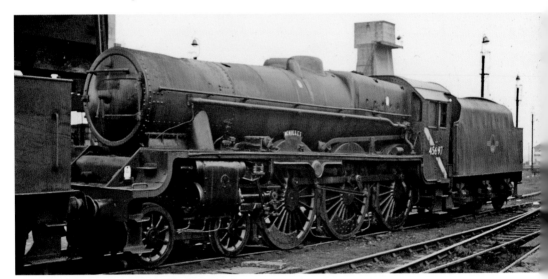

February 1968. LMS Stanier Jubilee 4-6-0 45697, Normanton MPD.
LMS Stanier Jubilee 4-6-0 45697 *Achilles* was built at Crewe Works in April 1936. It served in the North West for many years, including a ten-year stay at Carlisle Kingmoor before its reallocation to Holbeck MPD in March 1964. It was one of the Jubilees Holbeck kept in immaculate condition and worked throughout the summer over the Settle & Carlisle line. It was withdrawn in September 1967 with the closure of Holbeck to steam and stored at Normanton before disposal. It had already lost its chimney and in early 1968 would pause on its journey to Cashmore's of Great Bridge at Tyseley to relinquish more parts to aid the restoration of classmate 45593, which had been purchased for preservation.

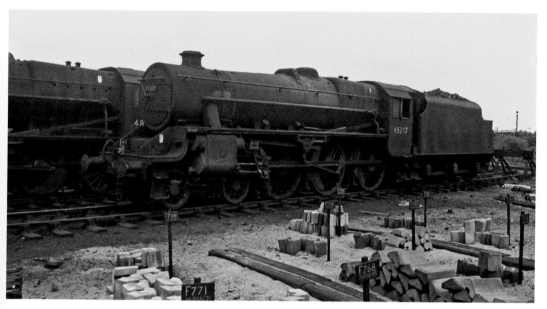

May 1966. LMS Stanier Black Five 4-6-0 45207, Royston MPD.
LMS Stanier Black Five 4-6-0 45207 was built by Armstrong Whitworth in November 1935. It was a West Yorkshire-based locomotive throughout its British Railways career, resident at Low Moor, Mirfield and Wakefield before reallocation in September 1963 to Royston MPD. It was withdrawn from Royston in October 1966 and was cut up at Drapers of Hull in December of that year.

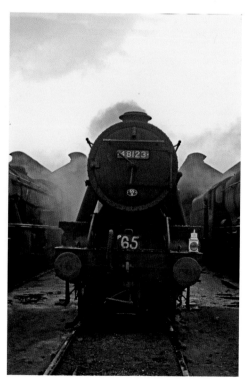

10 July 1966. LMS Stanier 8F 2-8-0 48123, Royston MPD.
LMS Stanier 8F 2-8-0 48123 was built at Crewe Works in June 1939 and began its British Railways career at Normanton before moving to Royston in September 1957. It was withdrawn in March 1967 and would languish in the sidings until towed away to Drapers of Hull in July 1967, being scrapped the following month.

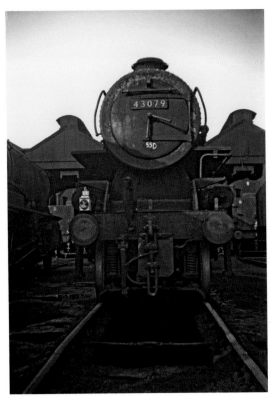

10 July 1966. LMS Ivatt 4MT 2-6-0 43079, Royston MPD.
LMS Ivatt 4MT 2-6-0 43079 was built for British Railways at their Darlington Works in October 1950 and put to work from Hull's Dairycoates depot. Its only reallocation came in October 1965 to Royston MPD, where it was withdrawn in December 1966. Its final journey was back to Hull and the Sculcoates yard of Drapers where it was cut up in April 1967.

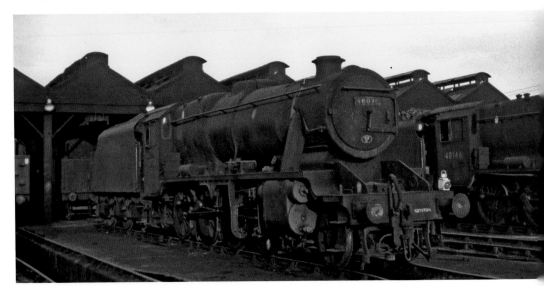

13 November 1966. LMS Stanier 8F 2-8-0 48070, Royston MPD.
LMS Stanier 8F 2-8-0 48070 was built by Vulcan Foundry in November 1936. The formation of British Railways in 1948 saw the locomotive allocated to Holbeck MPD, with its only move being to Royston in July 1954. It was finally withdrawn in November 1967 when the depot closed to steam and it joined the ranks of its stored 8Fs until April 1968 when it was dispatched to Cashmore's of Great Bridge for scrapping.

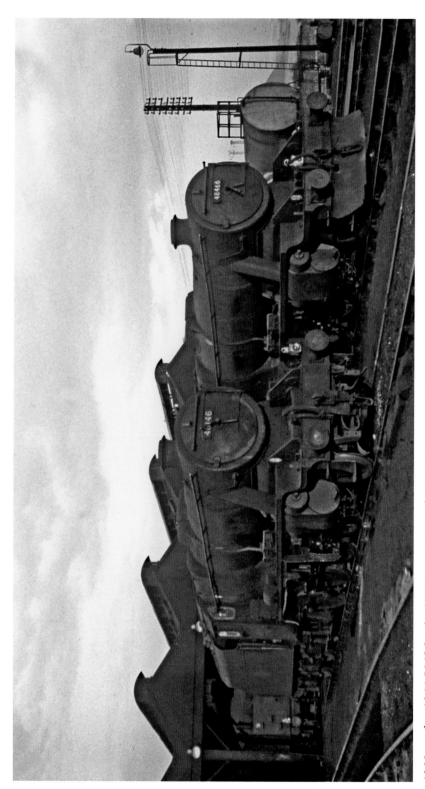

13 November 1966. LMS Stanier 8F 2-8-0s 48146 with 48466, Royston MPD.
LMS Stanier 8F 2-8-0 48146 was a product of Crewe Works in July 1942. It was allocated to Normanton and came to Royston in February 1954, being moved to Stourton in March 1965. When it was photographed outside the depot, it had just been reallocated back to Royston and was withdrawn two months later. 48466 had been built at Swindon Works in February 1945 and was a long-term resident of Royston, arriving there in September 1951 and finally being withdrawn in May 1967.

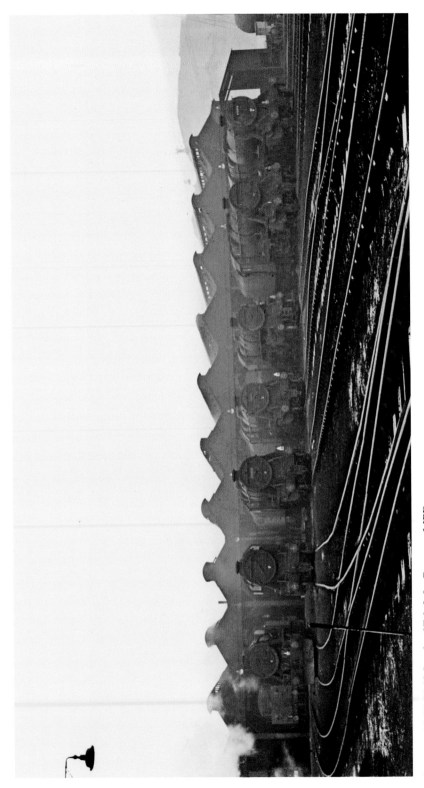

January 1967. LMS Stanier 8F 2-8-0s, Royston MPD.
LMS Stanier 8F 2-8-0s dominate the scene at Royston on a bitterly cold Sunday afternoon. The five 8Fs along with the WD and Ivatt 4MT were being lit up and prepared for the next working week. There were engines inside the shed quietly hissing and occasionally making loud cracking sounds as they gradually warmed through. In less than a year this hive of activity would be gone and the locomotives would be lined up cold and cast aside, waiting for the cutter's torch. (L. Flint)

January 1967. Ice formed on LMS Stanier 8F 2-8-0, Royston MPD.

The bitterly cold weather had frozen the water dripping from leaking tender of the LMS Stanier 8F 2-8-0. The sleepers, rails and tender steps were covered in ice and yet the shed staff continued to prepare the engine for its next duty. Such working conditions were taken for granted, with men and machines achieving their best despite the harshest of weather. (L. Flint)

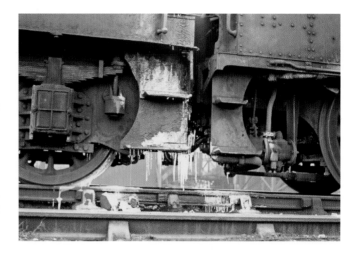

19 February 1967. LMS Stanier 8F 2-8-0s 48093 with 48439, Royston MPD.

LMS Stanier 8F 2-8-0s 48093 and 48439 keep company with at least four more of their classmates as they are being prepared for the next working week. Royston MPD was the last shed in the West Riding to use steam and 4 November 1967 saw the last 8F-hauled goods train leave for Goole. (L. Flint)

19 February 1967. WD 2-8-0 90680, Royston MPD.

WD 2-8-0 90680 was built by Vulcan Foundry for the War Department as 79214 in November 1944. It was to work on the Belgian State Railway before returning to England in 1947. After being overhauled it was allocated to Huddersfield Hillhouse in October 1949, where it remained faithful until the depot closed in December 1966. It was transferred to Royston in January 1967 but saw little use and was withdrawn in April 1967, being scrapped at T. W. Ward of Killamarsh. (L. Flint)

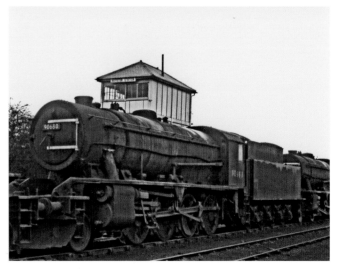

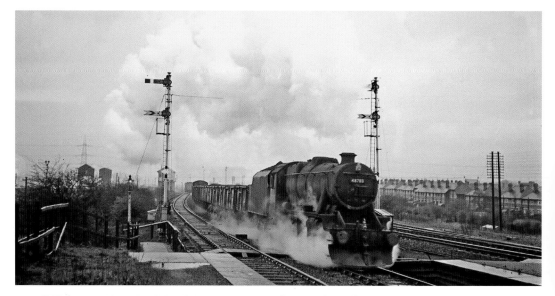

17 February 1967. LMS Stanier 8F 2-8-0 48703 hurries through Royston.
LMS Stanier 8F 2-8-0 48703 rattles its train through Royston station with the depot on the left of the photograph. 48703 was a product of Brighton Works in June 1944; it had been a West Yorkshire locomotive throughout its British Railways career. It was based at Holbeck MPD for a couple of years and then in January 1950 was transferred to Stourton, where it remained until that depot closed to steam. By January 1967 it had become part of the Royston stud of 8Fs and was withdrawn from there in September 1967.

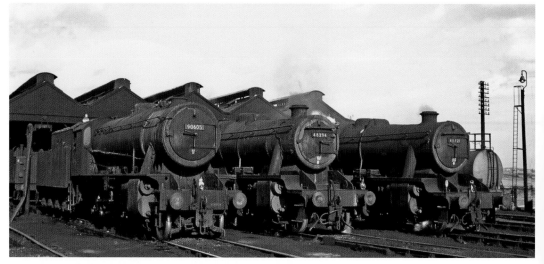

26 February 1967. WD 2-8-0 90605 with LMS 8F 2-8-0s 48394 and 48721, Royston MPD.
LMS Stanier 8F 2-8-0s 48394 and 48721 keep company with WD 2-8-0 90605 on a bright Sunday afternoon in late February. 90605 had been a Royston locomotive since July 1959, but was to move on to Normanton within days of the photograph. From there, it was withdrawn in September 1967. Both the 8Fs had been reallocated from Stourton in October 1966 just before that depot closed; 48394 would be withdrawn in June 1967 and 48721 three months later in September 1967.

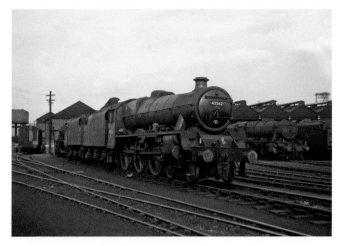

March 1967. LMS Stanier Jubilee 4-6-0 45562, Royston MPD.
LMS Stanier Jubilee 4-6-0 45562 *Alberta* from Leeds Holbeck shed worked into Royston with a goods train on one of the many less glamorous tasks it was to undertake in its last year in service. The diagonal warning stripe on the cabside meant that the loco was forbidden from working under overhead power lines south of Crewe.

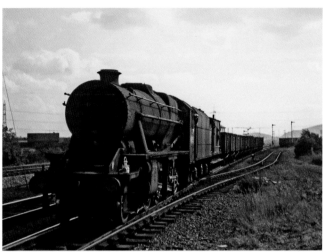

4 September 1967. LMS Stanier 8F 2-8-0 48540 shunts at Royston.
LMS Stanier 8F 2-8-0 48540 was built at Darlington Works in December 1944 and spent its entire British Railways career working from Royston MPD. It was to be one of the last active locomotives there and was withdrawn when the depot closed in November 1967. It was finally cut up at Cashmore's of Great Bridge, Birmingham, in April 1968.

3 November 1967. LMS Stanier 8F 2-8-0 48276, Royston MPD.
LMS Stanier 8F 2-8-0 48276 was built by the North British Locomotive Company in July 1942; it spent its entire British Railways working life based in West Yorkshire, first at Stourton then Mirfield, Low Moor and Wakefield. With the closure of Wakefield MPD in June 1967 it moved for one last time to Royston. It was seen in the yard at Royston devoid of a smokebox number plate and days away from withdrawal, which came with the closure of the depot to steam.

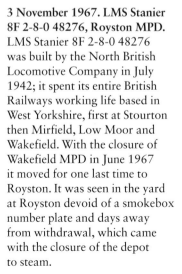

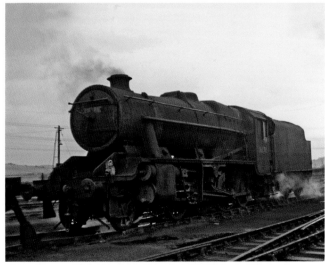

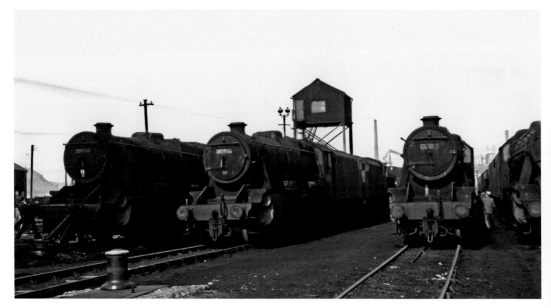

April 1968. LMS Stanier 8F 2-8-0s, Royston MPD.
LMS Stanier 8F 2-8-0s stored at Royston five months after the closure of the depot to steam. They wait in silent rows, ready to be removed to various scrapyards around the country. In October 1967 the Eastern Region had just twenty-one steam locomotives based at its depots; of these, seventeen were 8Fs allocated to Royston – the last major steam depot in the region. By the end of November 1967, this last bastion of steam in West Yorkshire had closed.

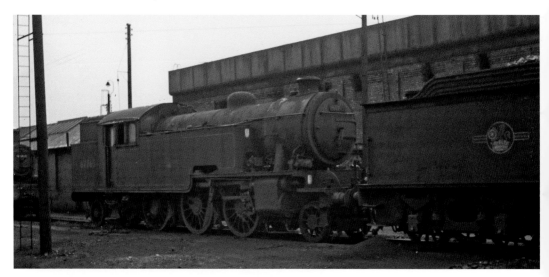

12 May 1963. LNER L1 2-6-4T 67765, Wakefield MPD.
LNER L1 2-6-4T 67765 was built for British Railways by the North British Locomotive Company in February 1949, and based in Hull. In June 1956 it was transferred to Middlesborough and began a nomadic career as it moved to Whitby, Thornaby, West Hartlepool and Darlington before its last move to Ardsley MPD in November 1961. It was withdrawn from Ardsley in November 1962 and was seen six months later at Wakefield while en route to Darlington Works for scrapping.

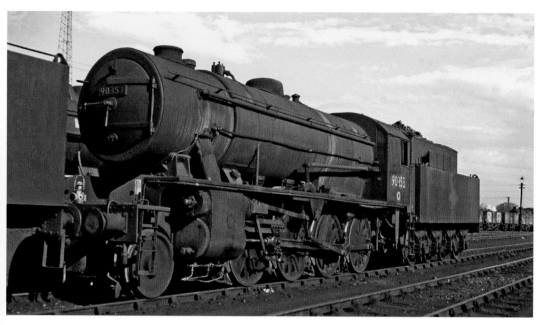

August 1963. WD 2-8-0 90353, Wakefield MPD.
WD 2-8-0 90353 was built by the North British Locomotive Company for the War Department as 77285 in March 1944. It was shipped to Europe to work on the Belgian State Railway from Tournai depot. On its return to England it was allocated to Wakefield MPD in July 1949, where it worked until withdrawal in February 1965.

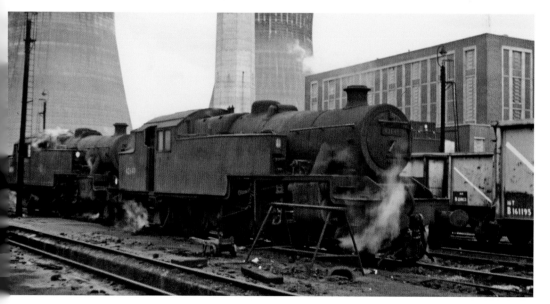

4 April 1964. LMS Stanier 4MT 2-6-4T 42649, Wakefield MPD.
LMS Stanier 4MT 2-6-4T 42649 was built at Derby Works in December 1938 and was allocated to depots around Manchester from new. In January 1955 it moved across the Pennines to Low Moor MPD and another reallocation in June 1960 brought it to Wakefield until January 1965. It was withdrawn a month later from Derby MPD in February 1965.

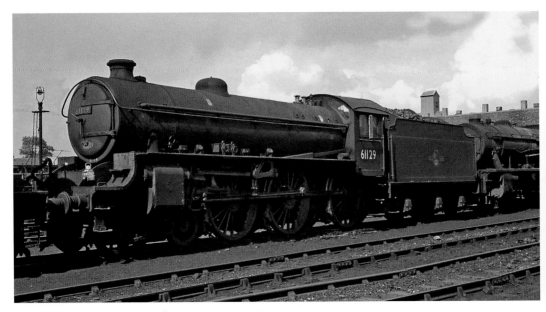

May 1964. LNER B1 4-6-0 61129, Wakefield MPD.
LNER B1 4-6-0 61129 was built by the North British Locomotive Company for the LNER in February 1947 and spent the first four years of its service working from Kings Cross depot. November 1951 brought it to Ardsley MPD and a further move in July 1952 saw it transferred to Copley Hill for almost twelve years. In January 1964 it moved for one last time to Wakefield and was withdrawn from there in September 1965.

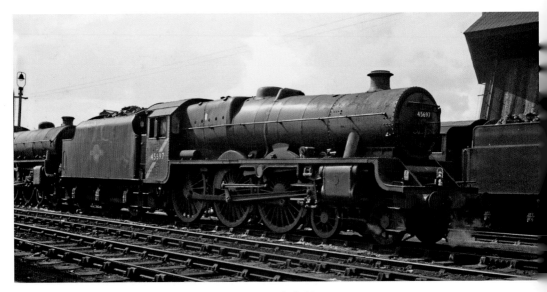

May 1964. LMS Stanier Jubilee 4-6-0 45597, Wakefield MPD.
LMS Stanier Jubilee 4-6-0 45597 *Barbados* was built by the North British Locomotive Company in January 1935 and in January 1948 it became a Holbeck-allocated locomotive. It was to remain at the depot throughout its British Railways career and was withdrawn in January 1965, which was too early for it to become part of the stud of Jubilees that performed so admirably up to the end of the summer timetable in 1967.

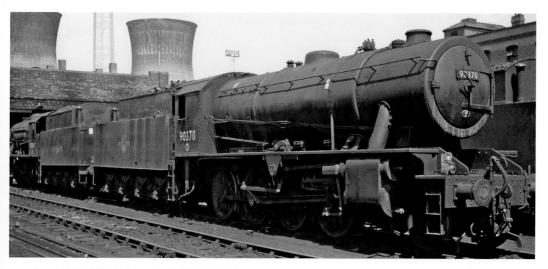

June 1964. WD 2-8-0 90370, Wakefield MPD.
WD 2-8-0 90370 was built by the North British Locomotive Company for the War Department as 78560 in September 1944. It was shipped to work on the Belgian State Railway from Ostend depot and on its return to England eventually joined the allocation of Wakefield MPD. It worked from Wakefield until December 1966, when it was transferred to Sunderland before finally being withdrawn from service in May 1967. It was seen with WD 90047, both having returned from Darlington Works after heavy overhaul in May 1964. Both locomotives carry the 'O' symbol on the cabside, denoting they are part of the pool of locos used on turns with crew bonuses for time keeping.

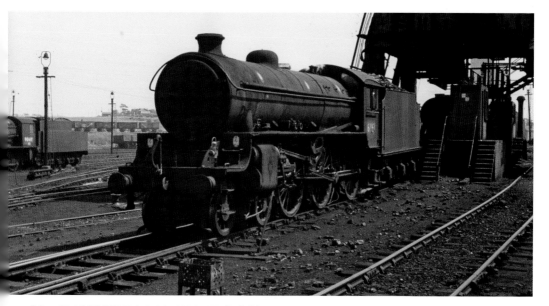

May 1966. LNER B1 4-6-0 61161, Wakefield MPD.
LNER B1 4-6-0 61161 was built by the Vulcan Foundry for the LNER in May 1947 and was allocated to Gorton MPD. In July 1960 it was transferred to Mirfield and eventually Wakefield in September 1961, where it worked until withdrawal from service in December 1966. Two months later it arrived at Arnott Young of Parkgate, Rotherham, for scrapping.

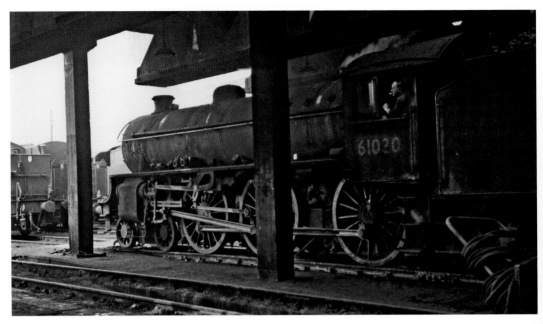

8 October 1966. LNER B1 4-6-0 61030, Wakefield MPD.
LNER B1 4-6-0 61030 *Nyala* had always been allocated to the North Eastern region. It became one of the last three active B1s when it ended its working days at Bradford's Low Moor MPD in September 1967. It was finally cut up by Garnham, Harris & Elton in Chesterfield in April 1968. It was seen in Wakefield depot, a timeless scene of man and machine in total harmony.

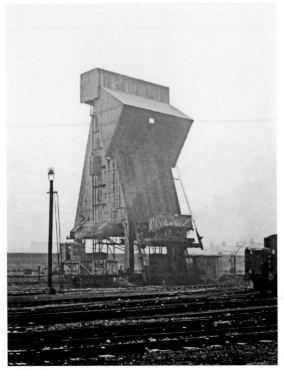

January 1967. The coaling tower at Wakefield MPD.
The low winter sunshine casts an unusual hue on the coaling tower at Wakefield depot. It was part of the 1932 improvement made by the LMS to the facilities for servicing locomotives. It replaced the coaling stage built by the Lancashire & Yorkshire Railway when they completed the depot in 1893. The massive concrete structure held 300 tons of coal and could replenish two locomotives at a time.
(L. Flint)

**January 1967. BR standard 2-10-0 92065.
Wakefield MPD.**
BR standard 9F 2-10-0 92065 was built at
Crewe in December 1955 – it was one of ten
9Fs fitted with two 10-inch Westinghouse air
compressors specifically to work the Consett
iron ore trains. When new it was diverted from
its Tyne Dock allocation to spend six months
covering for the Crosti 9Fs, which had been
taken out of service at Wellingborough. After ten
years working the iron ore trains, the 9Fs were
replaced by diesels and in December 1966 only
92065 remained in service. It was transferred to
Wakefield MPD and withdrawn in April 1967.
(L. Flint)

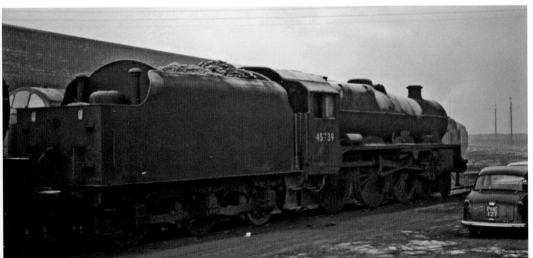

January 1967. LMS Stanier Jubilee 4-6-0 45739, Wakefield MPD.
LMS Stanier Jubilee 4-6-0 45739 *Ulster* was built at Crewe and entered service in December
1936 based at London-area depots. By January 1948 it was transferred to Holbeck MPD and
remained on their books until a final move in June 1964 brought it to Wakefield depot. On a
bitterly cold day in January 1967 it stands withdrawn complete with a tender full of coal. It
was to be the end of May before it was finally towed away to Draper's of Hull for scrapping.
(L. Flint)

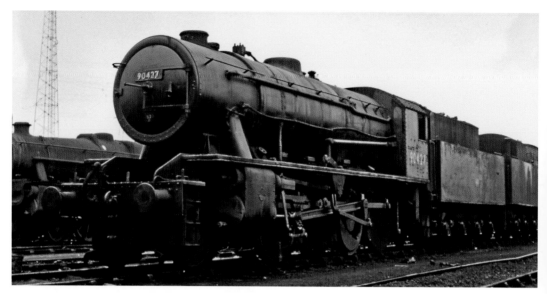

9 April 1967. WD 2-8-0 90427, Wakefield MPD.
WD 2-8-0 90427 was built by the Vulcan Foundry in October 1943 as 77112 for the War
Department. It was loaned to the LNER from new until January 1945 when it was shipped to
Belgium, though ultimately probably not used. It returned to England in December 1946 and
was bought by the LNER. It was a Hull-allocated engine from 1950 and then transferred to
Goole MPD in 1963, where it was to remain until the depot closed to steam at the end of May
1967. It was the last locomotive to work from the depot.

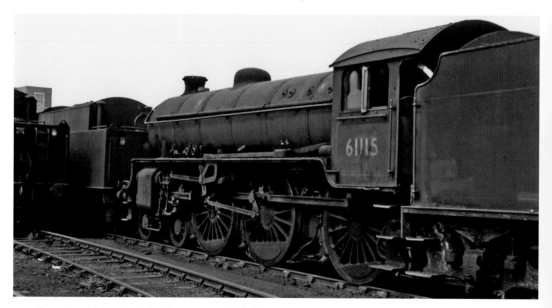

June 1967. LNER B1 4-6-0 61115, Wakefield MPD.
LNER B1 4-6-0 61115 was built by the North British Locomotive Company for the LNER
in January 1947. It was allocated to York MPD before moving to Copley Hill in June 1958
and then on to Low Moor in September 1963. Its final reallocation was to Wakefield MPD in
November 1966 and it was withdrawn from service in May the following year.

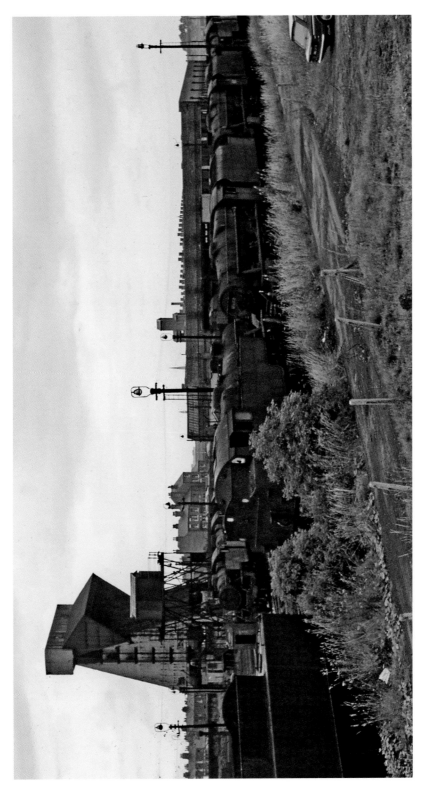

1 August 1967. General view of Wakefield MPD.
Wakefield MPD had closed to steam two months before this photograph was taken, yet the shed and yard were still overflowing with steam engines. They were all silent now though, withdrawn and cast aside waiting for their call to the scrapyard. Wakefield had become one of the main collecting points for withdrawn locomotives and there were regular movements of locos arriving and others departing. Very soon afterwards the engines had all gone and the yard resounded to the throbbing of large diesel engines. (L. Flint)

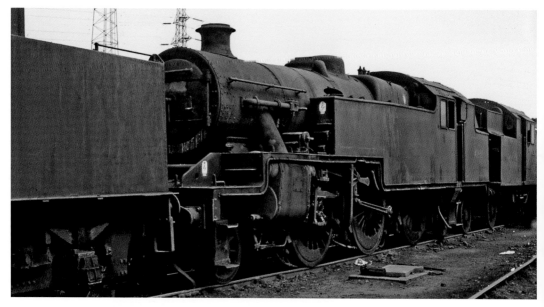

August 1967. LMS Stanier 4MT 2-6-4T 42650, Wakefield MPD.
LMS Stanier 4MT 2-6-4T 42650 was built at Derby in December 1938 and its career seemed to follow closely with its classmate 42649. They both spent time working in Lancashire at Bacup and Bury before arriving at Low Moor in January 1955. After six months at Copley Hill both locomotives were reallocated to Wakefield in June 1960. 42649 was withdrawn from Derby in 1965, but 42650 soldiered on at Wakefield and was eventually withdrawn in June 1967.

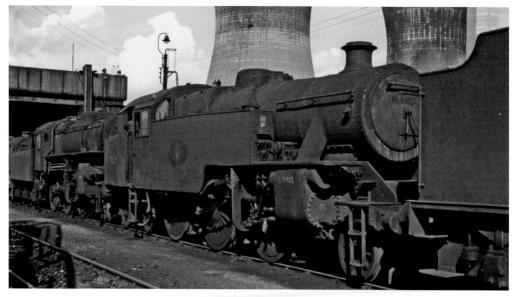

27 September 1967. LMS Fairburn 4MT 2-6-4T 42052, Wakefield MPD.
LMS Fairburn 4MT 2-6-4T 42052 was built at Derby Works in September 1950 and was based at either Bradford Manningham MPD or Holbeck MPD throughout its active life. It was withdrawn from Holbeck in May 1967, with damage to its right-hand cylinder the probable reason. It was enough to consign it to the scrap yard.

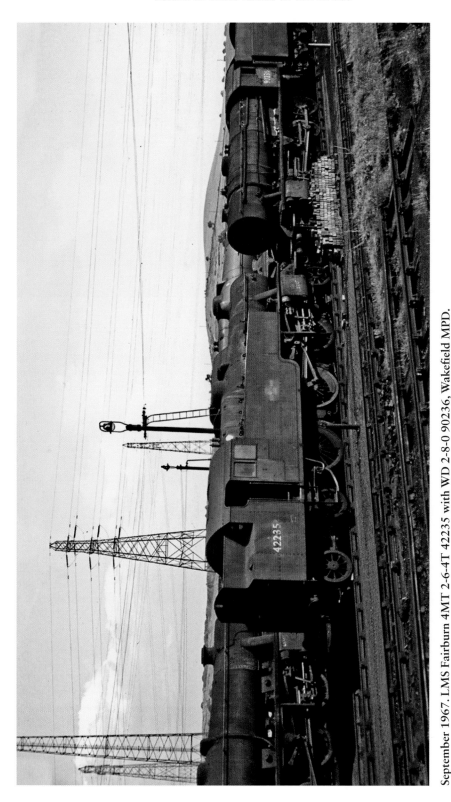

September 1967. LMS Fairburn 4MT 2-6-4T 42235 with WD 2-8-0 90236, Wakefield MPD.
LMS Fairburn 4MT 2-6-4T 42235 was a product of Derby in July 1946 and after spending time working from Stoke and Spring Branch, Wigan, it was reallocated to Wakefield in November 1966. The following month saw it transferred to Low Moor, but by July 1967 it was withdrawn and back at Wakefield with an ever-growing number of locomotives awaiting disposal to scrapyards.

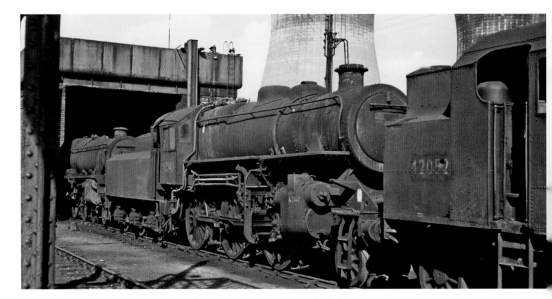

27 September 1967. LMS Ivatt 4MT 2-6-0 43140, Wakefield MPD.
LMS Ivatt 4MT 2-6-0 43140 was built at Doncaster Plant as late as August 1951 and was allocated to various depots in Scotland before reallocation to the North Eastern Region in October. This saw it serving at West Auckland, Thornaby, Darlington and Blyth. It was transferred to Stourton in June 1965 and remained there until the depot closed to steam in January 1967. It was withdrawn from Normanton MPD in June 1967 and headed for store at Wakefield MPD.

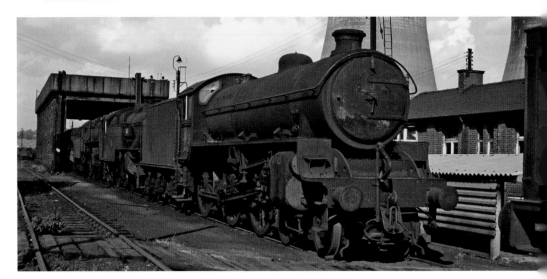

27 September 1967. LNER B1 4-6-0 61123, Wakefield MPD.
LNER B1 4-6-0 61123 was built by the North British Locomotive Company for the LNER in January 1947. It spent nearly four years working from Leicester G.C. and Colwick. Reallocation in September 1951 bought it to Ardsley MPD and in June 1962 it moved to Copley Hill. In January 1964 it became a Wakefield-based locomotive but moved on to York in January 1967. It was withdrawn from there in May of that year and returned to the now closed Wakefield shed for final disposal.

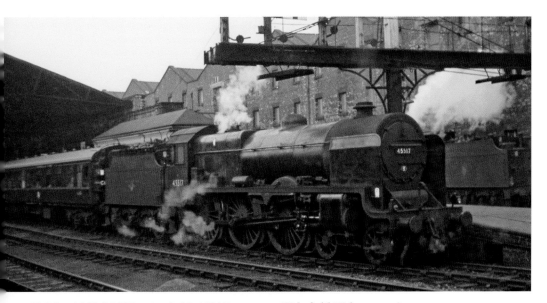

20 May 1961. LMS Patriot 4-6-0 45517 pauses at Wakefield Kirkgate station.
LMS Patriot 4-6-0 45517 was built at Crewe Works in February 1933 and its career saw it serve at various depots throughout the LMS area, from Willesden to Carlisle Upperby and from Aston to Edge Hill. In August 1958 it was reallocated to Bank Hall MPD and became a regular visitor to Yorkshire. It was often seen at York and Leeds and on one occasion I saw it working a short goods train through my hometown of Thorne, which in September 1961 seemed amazing! It was withdrawn in June 1962 and in August of that year was cut up in Crewe Works.

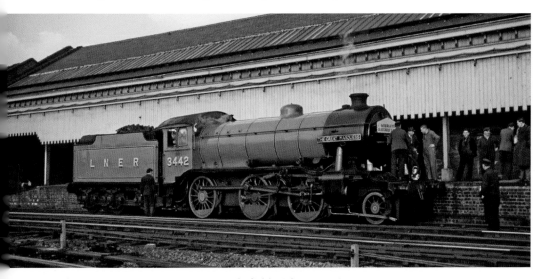

6 March 1965. LNER K4 2-6-0 3442, Wakefield Kirkgate station.
LNER K4 2-6-0 3442 *The Great Marquess* (61994) was bought privately by Lord Ganock in 1962 and overhauled in Cowlairs Works. It moved to Neville Hill depot in April 1963 and began to haul a series of special trains until boiler problems in 1967 caused a halt to these. It was seen at Wakefield Kirkgate about to take over the SLS Whitby Moors Railtour, which it hauled single-handed to Market Weighton and then on to Filey and Whitby aided by K1 62005 en route.

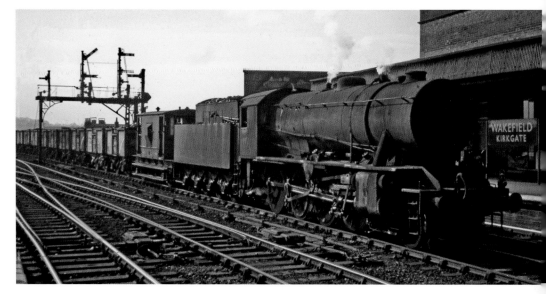

20 March 1966. WD 2-8-0 90074, Wakefield Kirkgate station.
WD 2-8-0 90074 was built by the North British Locomotive Company for the War Department
in August 1944 as 70872. It returned from its war service in Europe in late 1945 and by December
of that year had entered into the stock of the LNER at Newport depot and later Thornaby. It
moved to Wakefield in December 1963 but moved back to the North East in November 1966,
when it was transferred to Sunderland. It ended its working life at West Hartlepool, where it was
withdrawn in September 1967.

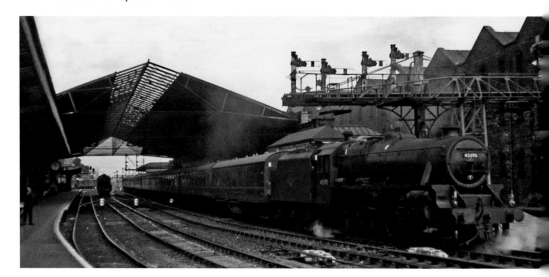

June 1966. LMS Stanier Black Five 4-6-0 45395 pauses at Wakefield Kirkgate station.
LMS Stanier Black Five 4-6-0 45395 was a product of Armstrong Whitworth for the LMS in
August 1937. It had been allocated to numerous depots across LMS territory in the intervening
years but went to Springs Branch, Wigan, in February 1966. It was seen on a passenger working
at Wakefield Kirkgate a month after its final overhaul at Crewe Works, where it had received an
unlined black livery. One last move took it to Edge Hill in December 1967 and it was eventually
withdrawn in March 1968, the last year of steam on British Railways.

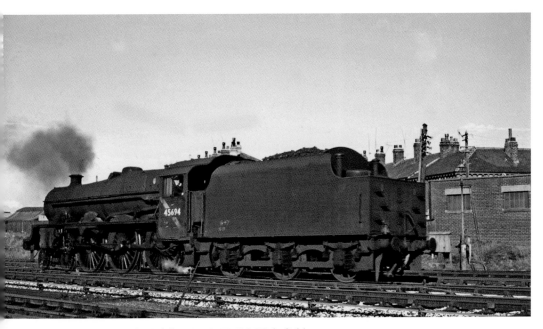

June 1966. LMS Stanier Jubilee 4-6-0 45694, Wakefield.
LMS Stanier Jubilee 4-6-0 45694 *Bellerophon* was built at Crewe Works in March 1936 and it was allocated to Holbeck depot at the dawning of the British Railways era. In July 1962 it was reallocated to Low Moor and then to Wakefield in February 1965. It was to miss the care and attention lavished on the Holbeck Jubilees but soldiered on until withdrawn in January 1967.

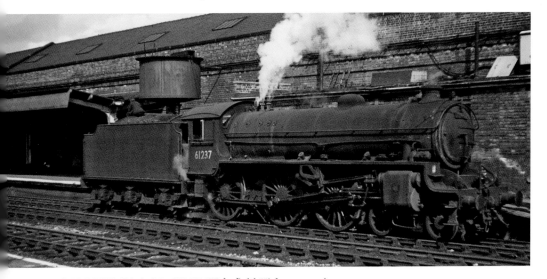

June 1966. LNER B1 4-6-0 61237, Wakefield Kirkgate station.
LNER B1 4-6-0 61237 *Geoffrey H. Kitson* was built by the North British Locomotive Company for the LNER and was allocated to Neville Hill MPD. From February 1961 it spent four years in the North East working from Gateshead, Sunderland, Blaydon and Tyne Dock. It returned to the West Riding in December 1964 to Ardsley depot and a year later moved to Wakefield. It was withdrawn from Wakefield in December 1966 and scrapped by Arnott Young of Parkgate, Rotherham.

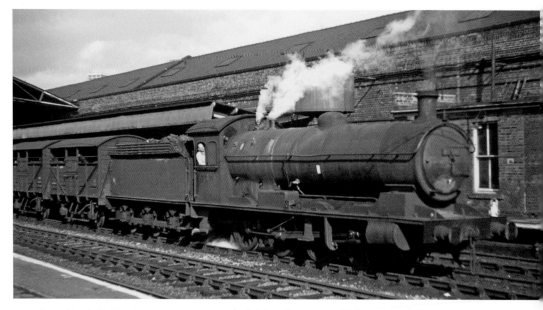

June 1966. LNER Q6 0-8-0 63426, Wakefield Kirkgate station.
LNER Q6 0-8-0 63426 was built by Armstrong Whitworth for the NER in April 1920 and in its long career worked from a number of depots in the North East. In December 1962 it moved down to Neville Hill MPD and from June 1966 spent four months allocated to Normanton. October 1966 saw it return to the North East at Tyne Dock, where it was withdrawn in June 1967. It was cut up in Chesterfield at the yard of Garnham, Harris and Elton.

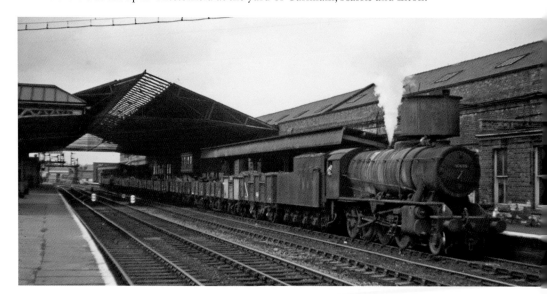

June 1966. WD 2-8-0 90679, Wakefield Kirkgate station.
WD 2-8-0 90679 was a product of the Vulcan Foundry for the War Department as 79213 in November 1944. It was allocated to Wakefield on entering British Railways service and in October 1953 it moved to Goole. By February 1956 it was back at Wakefield, where it remained until February 1966 when its final transfer took it to Mirfield from where it was withdrawn in September 1966.

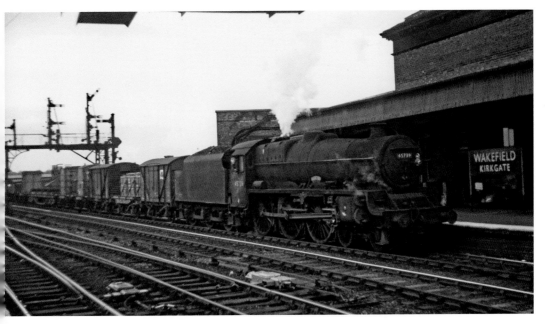

14 June 1966. LMS Stanier Jubilee 4-6-0 45739, Wakefield Kirkgate station.
LMS Stanier Jubilee 4-6-0 45739 *Ulster* had been resident at Wakefield MPD since June 1964 having spent the previous sixteen years at Holbeck depot. In deplorable external condition and sporting a hand-painted nameplate it was seen working a very mixed fitted goods train through Kirkgate station.

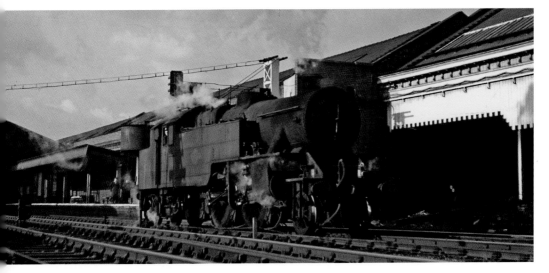

February 1967. LMS Fairburn 4MT 2-6-4T 42287, Wakefield Kirkgate station.
LMS Fairburn 4MT 2-6-4T 42287 was a product of Derby Works in October 1947 and was allocated to Lancashire depots during its career. In common with other locomotives, it had migrated to West Yorkshire for the last few months of its working life. It was transferred to Wakefield in December 1966 but was withdrawn in July 1967, joining the ever-growing rows of redundant steam locomotives stored around Wakefield MPD. It was dispatched to Draper's of Hull in January 1968 and cut up within a week of its arrival there.

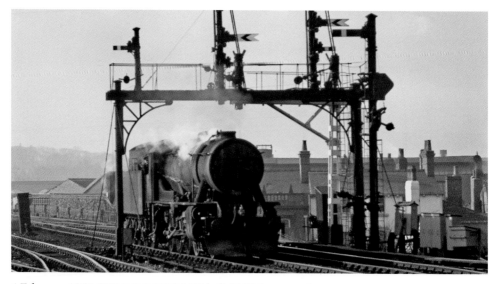

4 February 1967. WD 2-8-0 90397, Wakefield Kirkgate station.
WD 2-8-0 90397 was built by the North British Locomotive Company for the War Department in December 1944 as 78605 and worked on the Belgian State Railway from 1945 until it returned to England in 1947. It began its career as a British Railways locomotive in September 1949, allocated to Wakefield before moving to Goole in November 1954 and later Low Moor. It spent eighteen months in the North East working from Darlington and Thornaby. By November 1959 it was back on familiar territory being reallocated to Mirfield. It was to return to Wakefield in February 1967 and was withdrawn in May of that year. It is unclear when the locomotive acquired the GWR-style fire-iron cover as it had spent most of its life in West Yorkshire.

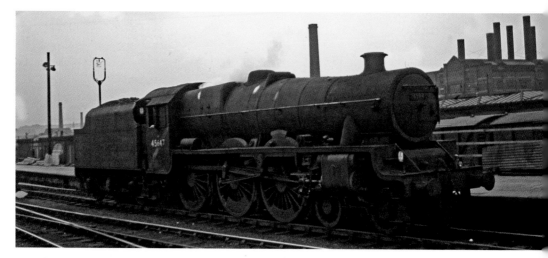

21 May 1965. LMS Stanier Jubilee 4-6-0 45647, Wakefield Westgate station.
LMS Stanier Jubilee 4-6-0 45647 *Sturdee* was a product of Crewe Works in January 1935 and was reallocated to Farnley Junction MPD in February 1964. It was seen heading through Wakefield Westgate station before its reallocation to Holbeck and the last summer of the Jubilees. Unfortunately, 45647 did not see the summer in service because it was withdrawn in late April 1967 and was stored at Wakefield before its final journey to Cashmore's of Great Bridge in August of that year.

29 March 1966. LMS Stanier Jubilee 4-6-0 45697, Wakefield Westgate station.
LMS Stanier Jubilee 4-6-0 45697 *Achilles* was built at Crewe Works in April 1936 and was reallocated to Holbeck MPD in April 1964. It was to work through the summer of 1967 before it was withdrawn in September. It was stored at Holbeck and then at Normanton before it was dispatched for scrapping at Cashmore's in Great Bridge.

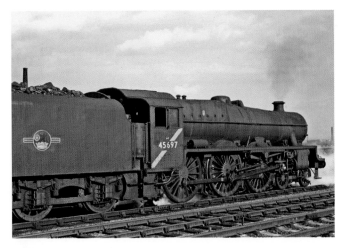

23 August 1966. LNER B1 4-6-0 61388 stops at Wakefield Westgate station.
LNER B1 4-6-0 61388 was built by the North British Locomotive Company for British Railways in November 1951. It was allocated first to Ardsley MPD and the following year to Copley Hill, where it stayed for seven years. It returned to Ardsley in November 1962 before moving to Low Moor in November 1965. Its final reallocation was to Wakefield in December 1966, and it was withdrawn from there in June 1967.

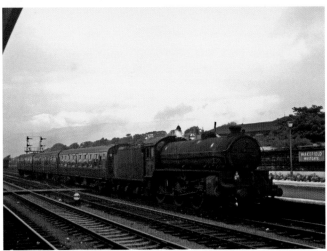

13 June 1967. LMS Stanier Black Five 4-6-0 44694 passes Wakefield Westgate station.
LMS Stanier Black Five 4-6-0 44694 was built at Horwich in November 1950 and was a Low Moor-allocated locomotive for most of its career. It was to be withdrawn from Low Moor with the closure of that depot to steam in October 1967.

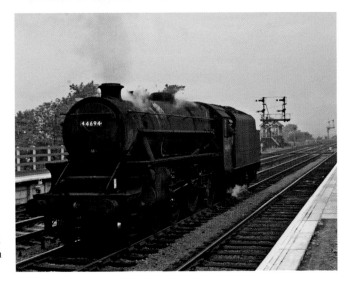

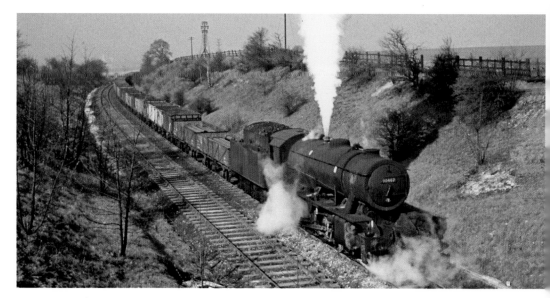

25 March 1962. WD 2-8-0 90407 near Upton.
WD 2-8-0 90407 was built by the North British Locomotive Company for the War Department in January 1945 as 78624. It was transferred from store in Belgium in late 1945 to work on the French State Railway until it returned to England in 1947. It became a British Railways locomotive allocated to Farnley Junction in April 1950 and moved to Royston in November 1961. After two years at Royston it was reallocated to Wakefield, where it remained until withdrawal in May 1967. (M. Fowler)

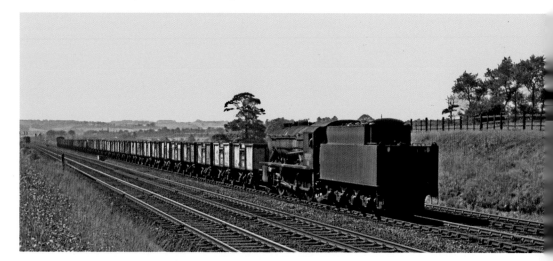

27 August 1965. WD 2-8-0 90210 heading east at Thornes, Wakefield.
WD 2-8-0 90210 was built by the North British Locomotive Company for the War Department in November 1943 as 77252 and was loaned to the LNER. It worked from St Margaret's MPD, Edinburgh, until it was returned to the WD in January 1945 for service in Europe. After working on the Netherlands Railway it returned to England and was allocated to a number of depots in the North Eastern Region before becoming a Wakefield-based locomotive in January 1964. It returned to the North East in September 1966 and was withdrawn from West Hartlepool in June 1967.

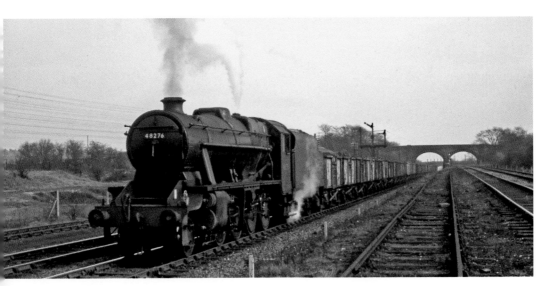

February 1967. LMS Stanier 8F 2-8-0 48276 on the outskirts of Wakefield.
LMS Stanier 8F 2-8-0 48276 was built by the North British Locomotive Company for the LMS in July 1942 and at the formation of British Railways was allocated to Stourton depot. In January 1960 it moved to Mirfield and in February was transferred to Wakefield. After the closure of Wakefield to steam in June 1967 it worked from Royston and when that depot closed in November 1967 it was withdrawn. The clean condition of the locomotive, so late in the life of steam in West Yorkshire, was unusual even when allowing for the fact that it had received an overhaul at Crewe Works the year previous to the photograph.

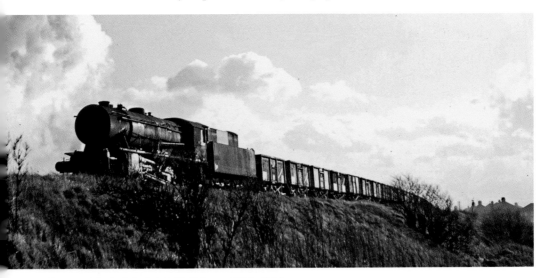

4 February 1967. WD 2-8-0 90409 near Wakefield.
WD 2-8-0 90409 was built by the North British Locomotive Company as WD 78532. It was loaned by the LNER in September 1947 and worked from Hull Dairycoates depot until December 1955, when it was transferred to York. It became a Wakefield locomotive in July 1965 and stayed on their books until the shed closed to steam in June 1967 when it was withdrawn. It was seen on a typical duty hauling empty mineral wagons to a local colliery and returning with another trainload of coal.

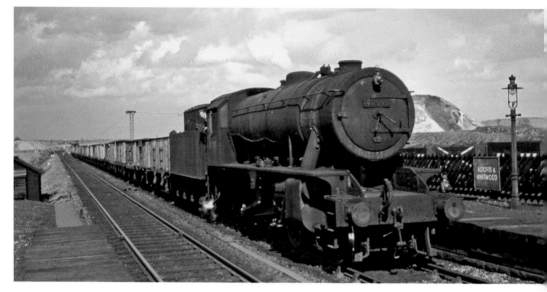

26 August 1963. WD 2-8-0 90595 clangs through Altofts and Whitwood.
WD 2-8-0 90595 was built by the Vulcan Foundry for the War Department as 77451 in December 1943. When new it was loaned to the LNER and in September 1944 it was loaned to the GWR. It was returned to the WD in January 1945 for service in Europe and returned back to England in 1947. It was allocated to Lostock Hall, Hellifield, and eventually Lancaster Green Ayre in January 1959. It was quite a way from home when working through Altofts and Whitwood station with empties for the colliery in the background.

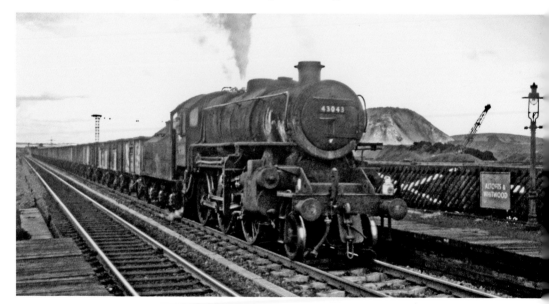

25 August 1966. LMS Ivatt 4MT 43043 Altofts and Whitwood.
LMS Ivatt 4MT 2-6-0 43043 was built at Horwich Works for British Railways in September 1949 and was allocated new to Heaton MPD. It moved to Holbeck in July 1957 and finally to Normanton in September 1964, where it was withdrawn in September 1967. It was seen bringing another string of empties to Whitwood colliery.